Classic Restaurants

OF

CHAPEL HILL and ORANGE COUNTY

Classic Restaurants
OF
CHAPEL HILL *and* ORANGE COUNTY

CHRIS HOLADAY AND PATRICK CULLOM

Foreword by Greg Overbeck, co-owner of the Chapel Hill Restaurant Group

AMERICAN PALATE

Published by American Palate
A Division of The History Press
Charleston, SC
www.historypress.com

First published 2020

Manufactured in the United States

ISBN 9781467143943

Library of Congress Control Number: 2020941805

Notice: The information in this book is true and complete to the best of our knowledge. It is offered without guarantee on the part of the authors or The History Press. The authors and The History Press disclaim all liability in connection with the use of this book.

As this book goes to press, the county—and the world—is in the midst of the COVID-19 pandemic. This is having a profound effect on the restaurant industry. Some establishments that are open as of this writing may not be when it is over. Our thoughts go out to all restaurant owners and employees in this very difficult time, and we dedicate this book to them.

Contents

Foreword

When my dad retired from the Air Force in 1966, my family moved to Charlotte, and I first heard of the University of North Carolina at Chapel Hill. As basketball player and fan, I soon adopted the Tar Heels and the legendary Dean Smith as the program and coach for which I would pull. I couldn't wait to actually see the university and the mythical town surrounding it, and I finally got a chance to visit when I attended a choral workshop on campus in 1969.

Franklin Street was a revelation to me. There were students everywhere, head shops and record stores, street musicians and the famous Flower Ladies selling fresh blooms out of buckets of water on the sidewalk. I only visited one restaurant on that trip: Harry's, a hamburger joint on Franklin Street with long-haired servers and cooks dressed in tie-dyed T-shirts and bandannas. It was a glimpse into a fascinating new world for me, and I was determined I would return to UNC and Chapel Hill. Three years later, I did as a freshman, and except for a few brief adventures, I've never really left the Southern Part of Heaven.

I was on the university meal plan my first semester, so I didn't eat out often, but by the time my second semester rolled around, I rejected the offerings of the food halls and started cooking in my dorm room and visiting some of the local restaurants. I remember the home cooking at Brady's, the fantastic rolls at the Porthole and bacon and brie omelets at the Carolina Coffee Shop with classical music in the background. I can smell the frying tortillas at Tijuana Fats and hear the sizzling Gambler

steak platter at the Rathskeller. I distinctly remember trying chitlins for the first (and only!) time at Mama Dip's Country Kitchen, before I learned to order the fried chicken and ribs at dinner and the hoop cheese omelet for breakfast. A special occasion was observed with a visit to Slug's at the Pines, a legendary steakhouse. Golden West was open twenty-four hours a day, and I'll never forget its amazing blueberry pancakes, usually enjoyed at very late-night or early-morning meals.

I graduated in 1977 and took a job with a college friend doing basic carpentry work, but I needed a second job and was hired as a busboy at Spanky's, a new restaurant on the corner of Franklin and Columbia. The owner was Mickey Ewell, who had started his career as a restaurateur with Harrison's, a restaurant and bar in the middle of Franklin Street. Within weeks, I was waiting tables, bartending and even pulling some shifts in the kitchen, and I soon left my carpentry job. I met a new employee, Pete Dorrance, who to this day is the funniest person I've ever known, and we formed an immediate friendship. His lifelong friend Kenny Carlson moved down from Connecticut, and we all rented a house and managed Spanky's as a team for several years.

I spent a lot of time there, of course, but I still visited many other local eateries. I enjoyed breakfasts at Breadmen's, wonderful vegetarian offerings at Pyewacket and memorable meals at Papagayo. Bill and Moreton Neal opened the iconic La Résidence in 1977, and Aurora opened on Franklin Street before moving to Carr Mill Mall. Four Corners, named after Dean Smith's brilliant (but frustrating) offense, became a Franklin Street mainstay. Sutton's Drug Store excelled with counter seating for sandwiches, wraps and burgers. Other long-gone restaurants I frequented included Four Thieves, Sadlack's Heroes and Avanti Gardens.

Eventually, Pete, Kenny and I wanted to open our own restaurant, and thankfully, Mickey offered us a partnership and suggested we look at a property on 15-501. We knew Chapel Hill and the Triangle needed a seafood restaurant, and we decided on a mix of a coastal oyster bar; the New England traditions of live lobsters, chowder and broiled scrod; and Calabash-style fried seafood with the requisite hush puppies. Squid's opened in 1986 and was an immediate success.

Mickey loved a D.C. restaurant that made its pasta in-house and featured a wood-burning pizza oven, and we used that formula as the inspiration for 411 West Italian Café on Franklin Street in 1991. A few years later, we opened 518 West in Raleigh, followed by MEZ Contemporary Mexican in the Research Triangle Park (RTP). We then opened Page Road Grill

with our catering company, Chapel Hill Restaurant Group Catering, in the same facility.

I'm writing this as we're negotiating, by far, the most difficult problem we've faced in our entire careers, the coronavirus pandemic. Our newest project, LuluBangBang, an Asian concept in the RTP, is scheduled to open in the fall of 2020. It's hard right now to imagine what the world will look like in a few months, but we're hanging in there and counting on the many wonderful people in our organization, as we always have. The silver lining in this very difficult time has been, and continues to be, the support of our local communities.

Countless other restaurants have opened in Chapel Hill as the town and university have grown over the years, of course. Many are gone, and some have lived on. National chains have periodically tried to get a foothold in Chapel Hill, but the local residents and students have thankfully preferred the wonderful array of independent locally owned restaurants. Chris could write a separate book about any restaurant I've mentioned in this foreword, and it would be filled with unbelievable stories about employees and customers.

Many people have approached me over the years and told me they're interested in getting into the business, and I always ask them one question: "Why in the hell would you want to get into the restaurant business?" The answer is never right. It's some dream of cooking or entertaining and never includes the late hours, the financial strain, the endless hours of operations, the crunch of food and labor costs or the tight margins for profit. The restaurant business has the highest rate of failure of any industry in the United States, and it has the deserved reputation of being a brutal business. But when it works, it's fun, exciting and immensely rewarding, and your employees become like family. Here's to all of the wonderful people I've had the pleasure of working with over the years in Chapel Hill, especially Mickey, Pete and Kenny and our managing partners, Tommy O., Zog, Jamie and Jen. You've added more to my life than you'll ever know.

—Greg Overbeck

Greg Overbeck, co-owner and marketing director for the Chapel Hill Restaurant Group, has been involved in the town's restaurant industry for over 40 years.

Acknowledgements

We would like to thank the many people who shared their memories of Chapel Hill restaurants or assisted our research: Victoria Bouloubasis, Lee Smith, Hal Crowther, Marilyn Markel, Sarah Dessen, Josh Wittman, Mel Melton, Greg Overbeck, Fran McCullough, Avery Danziger, Jim Parker, Molly Weybright, James McWhorter, Danny Rosin, Alison Brewbaker, Todd Hierman, Lisa Hierman, Mike Knowles, Graham Flynt, Kim Scott, Shannon Fox, Sue Holaday and Dennis Hermanson.

We would also like to thank Kate Jenkins, our editor at The History Press, for her guidance and patience. Many thanks go to Bob Anthony, curator of the North Carolina Collection at the Wilson Special Collections Library, University of North Carolina at Chapel Hill, as well as the staff of the Digital Production Center, for making Wilson Library's unique collections accessible and available for research. The *Durham Herald* photograph collection was immensely helpful.

Introduction

In 2016, *Daily Tar Heel* reporter Molly Weybright wrote, "I'm convinced I could live in Chapel Hill for the rest of my life and still not be able to eat at all of the restaurants in the city." Though meant as an exaggeration, there might be some truth to the statement; for a town its size, Chapel Hill has a tremendous number of restaurants. When the other two nearby municipalities in Orange County, Carrboro and Hillsborough, are included, the area becomes even more of a culinary destination. From breakfast spots to lunch cafés to fine-dining restaurants to late-night snack destinations, the Chapel Hill area has it all.

One of the most important things about restaurants is the sense of community they help build. From those that serve neighborhoods to the ones located downtown that are frequented by groups of students, restaurants can mean so much to people. They are the places where indelible memories are made. How many times restaurants are not associated with first dates, proms, graduations, wedding receptions or birthdays? Diners often have "their" restaurant, to which they are passionately loyal. It might be a place where they are known by the staff or one they visit regularly for a particular favorite dish. And mentioning dishes, everyone has their favorite in Chapel Hill, whether it is from one visit, four years of college or a lifetime of residency. Current choices would most certainly include Crook's Corner shrimp and grits, a BLT at Merritt's, a chicken biscuit at Sunrise Biscuit Kitchen or Time-Out, fried chicken at Mama Dip's or a burger from Al's Burger Shack. Even dishes that are no longer available have created memories that can

link multiple generations; a student who had a Greek grilled cheese from Hector's or the extra cheesy lasagna at the Rathskeller in the 1970s can discuss the meal with someone who did the same in the 1990s.

Researching restaurant history is very interesting, but it can be challenging. The food is the easy part. Countless reviews have been published, but the story of the restaurant itself can be more elusive. Restaurants are often quietly sold, and it can even be difficult to determine ownership.

And some locations have been home to numerous restaurants run by successive owners who each thought their vision would be the one that was successful. Many times while researching this book, a name of a restaurant would show up in old editions of the *Daily Tar Heel* or elsewhere and elicit a response: "Wow, I forgot about that place!"

As everyone who has ever owned their own eatery or worked in the industry will say, the restaurant business is tough. It may seem like a simple recipe for success—serve good food, and people will pay to come eat it— but there are so many more factors: the food, of course, but also location, price, economic conditions, competition and a niche in the market. Some restaurants just seem to run their course and fade in popularity while others remain customer favorites, despite being essentially unchanged for decades. Even in a basketball-crazy town such as Chapel Hill, a restaurant bearing the name of UNC's most famous player, Michael Jordan's 23, lasted only three years (1999–2002). On the other hand, Ye Olde Waffle Shoppe is nearing fifty years in business as of this writing. Even more remarkably, Carolina Coffee Shop, the oldest restaurant in the state, is closing in on a full century of serving Chapel Hillians. These places and many others have helped make the restaurant history of Chapel Hill and its neighboring towns a truly unique story.

1

Dining in Chapel Hill through the Years

The restaurant, as we think of it today, did not really exist in this country until the middle of the nineteenth century. The early ones—in cities like New York—were essentially reserved for the upper class and often served French food from menus written in French. Most people simply ate in their homes. Today, we frequently associate having an employee with the job of cooking for the individual or family as the domain of the wealthy. In the past, however, that was much more common in the middle class. Outside of the home, meals could often only be purchased in businesses designed to serve travelers, such as taverns and inns.

In Chapel Hill, because the town was essentially built around the University of North Carolina, the restaurant industry developed differently than it did in neighboring Durham. In Chapel Hill, most people associated with the university dined on campus. Durham, however, had a booming economy, thanks to the tobacco industry. To serve the growing working class there, restaurants began to appear in the late 1800s. Small cafés finally began to appear in Chapel Hill by the first decade of the twentieth century as the business district along Franklin Street grew. In 1922, the *Daily Tar Heel* stated, "Restaurants especially strive to keep pace with great increase in student body." The restaurants the article referred to numbered only three: Gooch's, White House Café and Carolina Cafeteria. With the dining options so limited in town, restaurants in Durham, Raleigh and Greensboro frequently advertised in the university newspaper at that time.

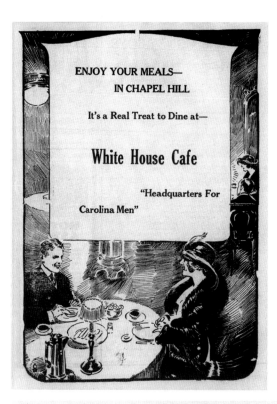

Apparently named after its two owners (Admiral Simms and Jimmie Howell), Sim-Jim Place began in the 1910s as a Franklin Street hot dog stand sheltered by a tent. In 1920, it moved into the building at 142 East Franklin Street that had been vacated by the U.S. Post Office. In 1921, it was sold to Jack Sparrow, who ran it as a self-named café for a year before selling to Durham restaurateur Tom Colones. He changed the name to White House Café, which ran this advertisement in the *Daily Tar Heel* in 1922. The following year, the name was changed again—to College Inn—when the business was purchased by Emmett Gooch. He owned the cafe next door and eventually combined the two businesses. *Courtesy Digital NC.*

GOOCH'S CAFE

Open Daily 7:00 A.M.-7:00 P.M.

Take home some of our Brunswick Stew and Barbecue.

Located Next to Old Bus Station on Columbia Street

The involvement of the Gooch family in the Chapel Hill restaurant industry included several generations and addresses. James Emmett Gooch opened his first small café in 1903 on North Columbia Street. In 1911, he moved to a larger space in the first block of East Franklin Street. In the early 1920s, he moved his business again a few doors east (beside what is now Carolina Coffee Shop). In the 1930s, the popular Gooch's Café relocated a third time, across the street to 153 East Franklin. In 1949, Gooch's Café returned to the west side of North Columbia Street near its original location, and the previous address was taken over by Danziger's Candy Shop. The last incarnation of Gooch's closed in the late 1950s. *The Carolina Handbook 1947–1948, University of North Carolina–Chapel Hill.*

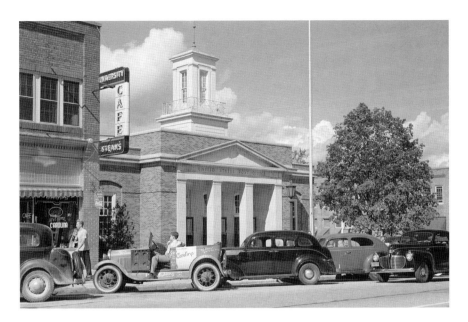

For much of the past one hundred years, the building just east of the post office at 175 East Franklin Street has been occupied by an eating establishment. Beginning in 1923, when it was built, it housed several cafeterias, including the Welcome In Cafeteria and the C&H Cafeteria. In 1938, it changed yet again to University Restaurant. *Photo by Marion Post Wolcott. Courtesy Library of Congress.*

In 1939, Edward "Papa D" Danziger, a recent immigrant from Austria, brought European flavor to Chapel Hill when he opened his Old World Candy Shop. The shop, located at 153 East Franklin Street, sold house-made confections, pastries, sandwiches, coffee and sodas. Its popularity soon led Danziger to expand and become a full-service restaurant called Danziger's Old World Restaurant. In the restaurant guide *Adventures in Good Eating*, Duncan Hines wrote that Danziger's was quaint, and its menu offered things such as Hungarian goulash, wiener schnitzel, sauerbraten, Czech meat roulade and Viennese coffee in a glass. Hines also made sure to point out that the establishment featured air conditioning.

After World War II, many soldiers returned from overseas with a taste for other flavors. The university also saw considerable growth in the late 1940s and '50s, with students arriving from other parts of the country. Restaurant-wise, this was important because it resulted in the introduction of pizza and other Italian dishes such as spaghetti and lasagna. Today, college and pizza seemingly go hand in hand, but it was not even available in Chapel Hill restaurants until around 1950. The Ram's Head Rathskeller

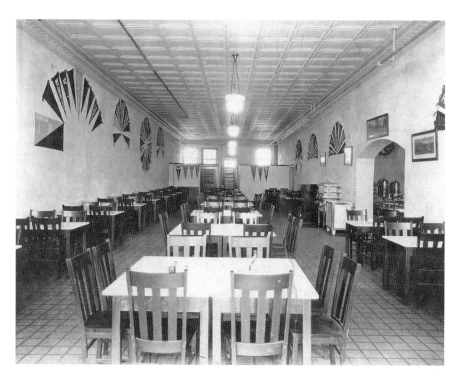

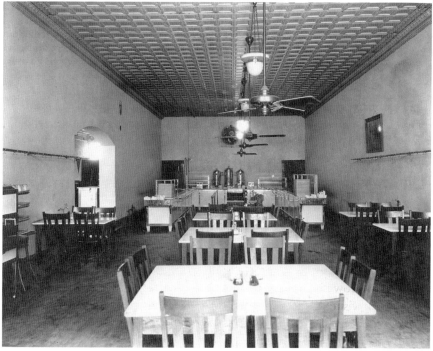

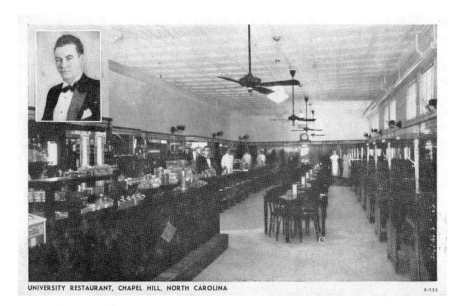

UNIVERSITY RESTAURANT, CHAPEL HILL, NORTH CAROLINA X-133

Opposite, top: Friendly Cafeteria, which also had locations in Durham, Greensboro, High Point and Winston-Salem, opened at 163 East Franklin Street in 1930. Off-campus cafeterias were a popular option with students in the prewar years, and they offered weekly or monthly three-meals-per-day dining plans, often for around for a dollar per day. *Courtesy Chapel Hill Historical Society Collection, Digital NC.*

Opposite, bottom: A view of the other room in Friendly Cafeteria. The eatery proved to be a short-lived venture and was replaced by Crescent Cafeteria in 1933. The space next became a bank before Milton's Clothing Cupboard called it home for more than forty years. In 1994, Franklin Street Pizza and Pasta moved in and had an eighteen-year run. It was followed by Tomato Jake's Pizzeria in 2012 and Ms. Mong's Mongolian Grill in 2015. *Courtesy Chapel Hill Historical Society Collection, Digital NC.*

Above: In 1938, the University Restaurant—complete with a tavern upstairs—opened in the Tankersley Building at 175 East Franklin Street. It closed in the early 1960s and was replaced by Harry's Grill, which relocated from two doors to the west. *Courtesy Durwood Barbour Postcard Collection, Digital NC.*

claimed to be the first eatery in town to serve pizza, and it also offered a popular (and unique) interpretation of lasagna.

It is almost impossible to count the number of pizza restaurants, local or chain, that have existed in Chapel Hill and Orange County in the years since. How many can say they never ate delivery pizza from P.T.A or Gumby's or visited Sal's or the Loop in Eastgate? Later, pizzerias began to get even more creative and elevated pizza beyond cheap college student fare. Pepper's was among the first to offer more unusual ingredients. More recent

INTRODUCING

Prices fitted to present economic conditions

THE CAROLINA COFFEE SHOP

Takes pleasure in announcing

The following new lower scale of prices:

BREAKFAST 15c - up
DINNER 30c - 40c
SUPPER 35c - 45c

WHY PAY MORE

Statistics show that college students can board cheaper and better in a cafe, than in any other form of eating establishment.

Saving on meal tickets, saving on all meals missed and an infinite saving to the temper by our wide range of

Choices For Every Meal

The Carolina Coffee Shop

(The place of Quality Food and Service)
$5.50 Meal Tickets, $5.00; $11.25 Meal Tickets, $10.00;
Six $5.50 Meal Tickets, $28.50

Left: In 1932, the Carolina Coffee Shop appealed to students dealing with the financial hardships of the Great Depression. This advertisement appeared in the *Daily Tar Heel*. *Courtesy Digital NC.*

Below: In 1939, Edward Danziger opened his establishment, a Viennese candy store/café, in the space formerly occupied by Emmett Gooch's restaurant. This postcard is circa 1940s. *Collection of the author.*

Opposite: Another circa 1940s postcard for Danziger's. *Collection of the author.*

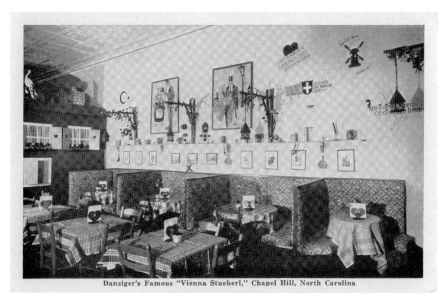

Danziger's Famous "Vienna Stueberl," Chapel Hill, North Carolina

22

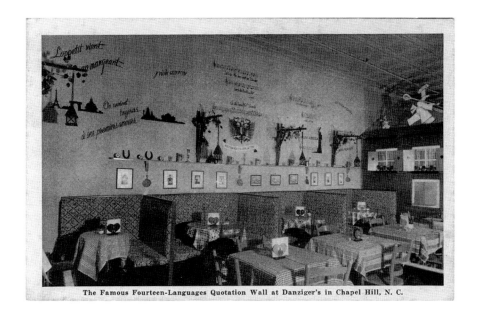

The Famous Fourteen-Languages Quotation Wall at Danziger's in Chapel Hill, N. C.

establishments, such as Pizzeria Mercato in Carrboro, have turned pizza into a true fine-dining experience.

But the story of Chapel Hill restaurants is not just about hard-working, fun-loving college students. Like all southern towns, Chapel Hill was burdened by the ugly specter of racial segregation for decades. Jim Crow laws kept Black and White customers separated, and Black people were denied service in establishments (or forced to order meals for takeout only, often from the back door). Many stuck to Black-owned establishments, such as the Starlite Supper Club or Bill's Barbecue, in the Northside neighborhood. Its business district was centered on the intersection of Graham and Rosemary Streets.

Mike Knowles, who grew up in Durham and attended UNC in the early 1960s, recalled the segregation of time: "My aunt and uncle ran the Pines Restaurant, Aunt Agnes and Uncle Leroy Merritt. I waited tables there when I was in undergraduate and on football game weekends when they were really busy. Some of my aunts and uncles were overtly racist, one in particular who worked in the tobacco factory. My uncle Leroy wasn't that bad, but he had pretty strong opinions. It was interesting, that same old southern story. The cook in the kitchen was Lewis, a big black guy, and his wife was named Mary. She sort of ran the kitchen. Perfectly wonderful working relationship but it was all very segregated."

Above and middle: Beginning in 1942, the University of North Carolina hosted a preflight school for U.S. Navy cadets who were preparing for service during World War II. Over fifteen thousand trainees passed through Chapel Hill in the three years that the program operated. These advertisements for local restaurants were aimed at those involved. They appeared in the newspaper of the preflight school, *Cloudbuster*, which was published from 1942 until 1945. *Courtesy Digital NC.*

Bottom: In 1947, the University Café advertised in the university's guidebook for new students. *The Carolina Handbook 1947–1948, University of North Carolina–Chapel Hill.*

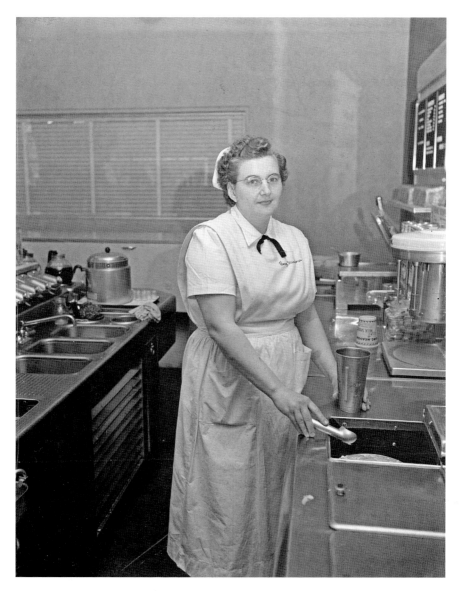

A server at Long Meadow Dairy Bar in 1953. The popular sandwich shop/ice creamery opened in the early 1950s at 431 West Franklin. It was in business until the late 1970s, and the location was eventually taken over by Pyewacket restaurant. *Courtesy Roland Giduz Photographic Collection, University of North Carolina–Chapel Hill.*

Beginning in the late 1950s, protests against segregation began to take place in the town. Long Meadow Dairy Bar, Colonial Drug, Leo's, Brady's and other restaurants were targets of protestors—both Black and White—for their policies. In fact, some of the most shameful incidents in the state took place at Watts Grill, just outside Chapel Hill. On January 2, 1964, a large group of UNC and Duke students marched down 15-501 to the grill to protest its segregationist policies. While trying to be seated, the group was met with hostility, and one student, a White UNC senior, was even knocked down and urinated on by one of the owners of the grill. The next night, a group of faculty protestors arrived at Watts Grill to show support for the students. On trying to enter the restaurant, UNC psychology professor Albert Amon was attacked by grill employees and received a vicious beating that required hospitalization. Several months later, he died of a brain aneurysm at age thirty-seven. Though suspected, it could not be medically proven that Amon's death was related to his injuries.

The events of the Watts Grill protests even led to an important Supreme Court decision. Peter Klopfer, a Duke University professor, was arrested for criminal trespass during the protest. For months, his case remained unresolved, leading Klopfer to sue on grounds that he should be guaranteed a speedy trial. The case, *Klopfer v. North Carolina*, eventually reached the Supreme Court in 1967. Justices unanimously agreed that states were obligated to uphold rights granted by the Sixth Amendment. The case was sent back to Orange County, where charges were dropped.

Not all Chapel Hill dining was segregated in the years before the Civil Rights Act officially ended the legality of Jim Crow laws in 1964. Once the university began admitting Black students, a group of town restaurateurs met in 1954 to discuss how they would deal with the situation if one of those students tried to dine at their establishments. At the meeting, Rathskeller manager B.C. Hedgepeth stated, "We will serve any neat and orderly student." According to an article years later in the *Carolina Alumni Review*, the Rat was then threatened with a lawsuit if it served a Black customer. The threat proved empty, however, and Hedgepeth stated in the article, "But we never had any problem." By at least 1958, three restaurants—the Rathskeller, Danziger's and Harry's—were integrated.

Famed singer Marian Anderson was reportedly the first Black person to be served at the Rathskeller in 1951. Avery Danziger, whose parents ran the Rathskeller, recalled that his father just didn't believe in judging a person based on anything other than their work. "So many Black employees stayed for years because of the way they were treated," he stated. "One, Robert

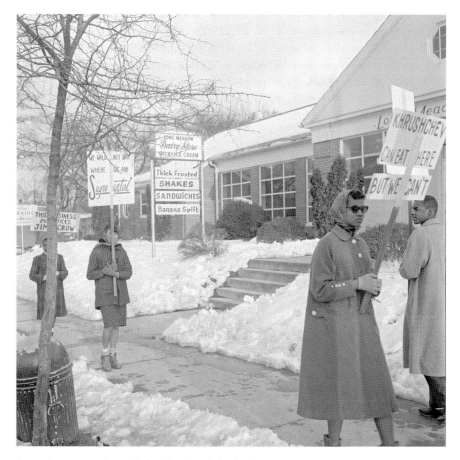

Protesting segregation at Long Meadow Dairy in February 1960. *Courtesy Roland Giduz Photographic Collection, University of North Carolina–Chapel Hill.*

Brooks, even went on to become head of the corporation that ran the Danziger restaurants. For any African American man to be afforded such opportunities was extremely unusual at that time."

In a 1981 *Daily Tar Heel* interview, Jim Cotten, who began working at the Rat in 1948, recalled that it was the only business in Chapel Hill to use the same restroom for Blacks and Whites, staff and customers. The restaurant was penalized by the health inspector for this, but Ted Danziger paid no attention. He was also the first to let Black employees work the cash register and open the restaurant.

In 1959, Dean Smith, then the assistant basketball coach, and his pastor, Reverend Robert Seymour, took a Black theology student to the Pines.

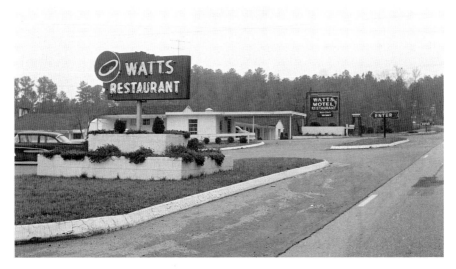

Watts Motel and Grill, taken in 1961. It was located on Highway 15-501, across from where Southern Village is now. *Courtesy Roland Giduz Photographic Collection, University of North Carolina–Chapel Hill.*

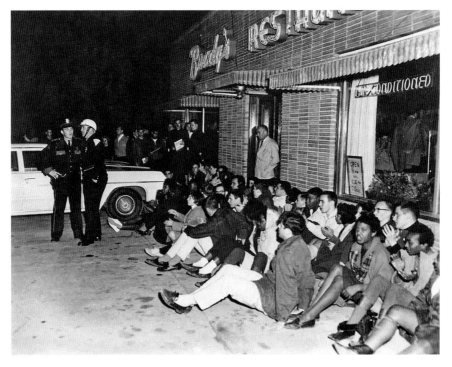

A protest at Brady's restaurant, 1964. *State of North Carolina Archives.*

A 1962 advertisement for Charlie Mason's Starlite Supper Club, a popular venue that served the Black community in Chapel Hill's Northside neighborhood. It often brought in well-known musical acts, and James Brown and Ella Fitzgerald reportedly performed there. Mason also owned a motel next door that served Black travelers. From *Hill's 1962 Chapel Hill City Guide. Courtesy Digital NC.*

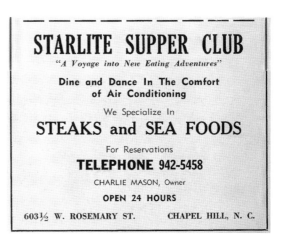

STARLITE SUPPER CLUB

"A Voyage into New Eating Adventures"

Dine and Dance In The Comfort of Air Conditioning

We Specialize In

STEAKS and SEA FOODS

For Reservations

TELEPHONE 942-5458

CHARLIE MASON, Owner

OPEN 24 HOURS

603½ W. ROSEMARY ST. CHAPEL HILL, N. C.

Seymour believed they would be seated because the segregated restaurant would not want to offend Smith and potentially loose the patronage of the basketball team. He was correct, and the trio was served. However, it was a one-off occurrence; no other Black person would be served in the dining room until after the passage of the Civil Right Act.

Even after the Civil Rights Act, the shadow of segregation certainly lingered. Black residents may have technically been allowed in southern restaurants but whether they were given a friendly welcome was a very different matter. In Chapel Hill, however, the university's position as a progressive leader helped change take place more rapidly than most places in the region. The public school system was fully desegregated by 1968, and in 1969, Chapel Hill residents elected the first Black mayor of a majority-White city in the South, Howard Lee.

In addition to racial strife, which often focused on restaurants, the other matter important to the dining industry in Chapel Hill in the 1960s was the arrival of chain restaurants. In 1940, the population of the town had been only 3,654. By 1960, however, it was over 12,000 and would double before the decade ended. This growth made it feasible for chains restaurants—both national and regional—to open locations in the town. The first two fast-food hamburger joints in town, Hardee's and Burger Chef, both opened in 1964. In 1964, Rinaldi's, a Kentucky Fried Chicken franchise, opened in Carrboro, while a franchise of Texas-based Pizza Inn opened at 208 West Franklin Street in 1968.

The 1970s were a time of change for the Chapel Hill restaurant scene. Previously, most restaurants had served similar food—the usual southern fare consisting of barbecue, fried chicken, some seafood, stewed vegetables,

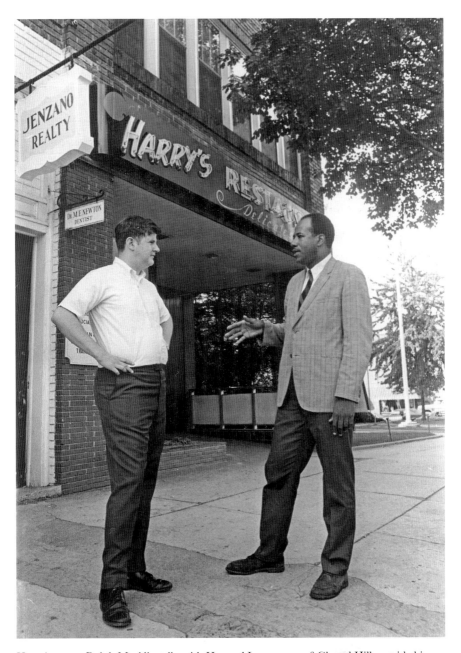

Harry's owner Ralph Macklin talks with Howard Lee, mayor of Chapel Hill, outside his restaurant in 1969. *Collection of the author.*

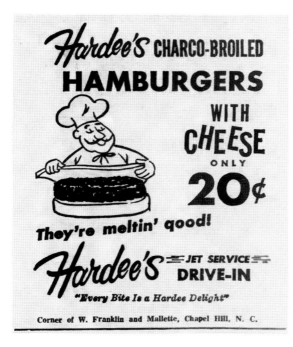

Left: A franchise of Rocky Mount–based Hardee's opened on West Franklin Street in 1964 and closed in the spring of 1999. This 1964 ad appeared in the *Daily Tar Heel*. *Courtesy Digital NC.*

Below: Honey's, part of a chain owned by Charlotte entrepreneur Y.L. Honey, opened in 1968 across Highway 54 from Glen Lennox shopping center. Gone by the early 1970s, it did not prove as successful as the Durham location, which was in business for over fifty years. *Courtesy Roland Giduz Photographic Collection, University of North Carolina–Chapel Hill.*

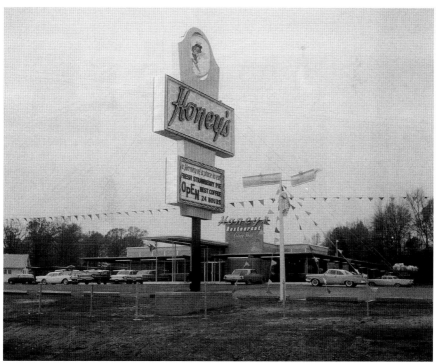

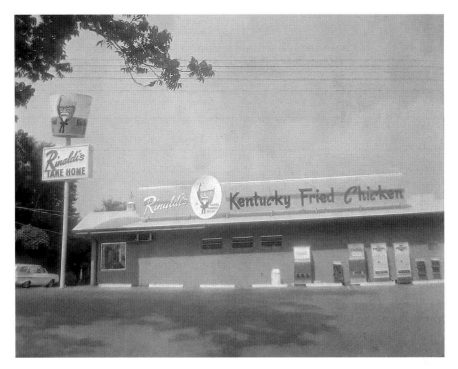

In 1963, Pete Rinaldi opened Durham's first Kentucky Fried Chicken franchise on Ninth Street. He soon followed that with another location in Carrboro (seen here) at the convergence of Franklin and Rosemary Streets. Rinaldi eventually owned several franchises before he sold them in 1969, at which time the Carrboro location became a Colonel Sanders–branded Kentucky Fried Chicken. The location still serves chicken in 2020 as a Wings Over Chapel Hill franchise. *Courtesy Roland Giduz Photographic Collection, University of North Carolina–Chapel Hill.*

et cetera. A fancy night out meant visiting a steakhouse. In the 1950s and '60s, the only deviation from this might have been an occasional pizza. But culinary trends were changing in the 1970s. The influence of flavors from outside the region became more common, much of it the cuisines of foreign countries making an appearance for the first time. In addition, natural or vegetarian food became more popular.

The first wave of immigrant restaurant owners, primarily from Greece, began in the 1930s. Southern diners were not ready for items like souvlaki and tzatziki sauce, however, so many of these early restaurateurs served "American" food. For example, Tommy Mariakakis served sandwiches and hot dogs in his Marathon Sandwich Shop at 115 East Franklin Street. It probably wasn't until his namesake restaurant opened in 1963 that Greek food began to appear on menus (though often in conjunction with Italian

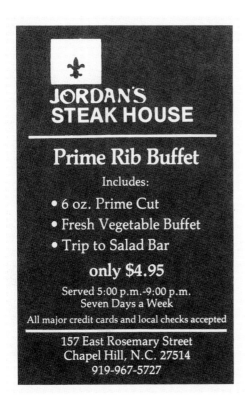

Jordan's was part of a late 1960s chain concept created by John Jordan, son of North Carolina senator Everett Jordan. His plan was to provide his steakhouses with beef from the Le Charolais cattle on his Alamance County farm. A few restaurants opened, including the Chapel Hill location in 1971. When the chain foundered in 1972, the Chapel Hill location was purchased by Clarence Daniel, who kept the name. For over fifteen years, Jordan's was popular for its prime rib and breakfast buffets and—perhaps most importantly to students—cheap mixed drinks ($1.25 highballs in the 1980s). It was often regarded as the place in town to impress a date. A 1977 advertisement even stated, "Take her to Jordan's where you and she can get steak for $10." It closed in 1988. *Collection of the author, 1986 advertisement.*

pizza). In the 1970s, the options grew, with Hector's offering Greek-style sandwiches, and more formal restaurants, such as Krissa on Rosemary Street, featuring a more expanded menu. Greek cuisine has played an important role in the dining scene of Chapel Hill ever since, with several later restaurants, including Zorba's and Kipos, carrying on the tradition.

One of the other international cuisines that is now popular as a dining option for students is that of China. In Durham, the first Chinese restaurant, called the Oriental, opened downtown in the late 1930s. It wasn't until 1970, however, that Chapel Hill had its own. That year, House of Chu opened at 1404 East Franklin Street and served rather Americanized versions of Chinese food. In 1977, another Chinese restaurant, Peking Garden, took over the location and offered a much more authentic menu. Today, Chinese food, which is often an economical choice for students, is extremely common.

Like all restaurants, some of those that specialize in the cuisine of China have had fleeting existences, while others have extremely long lives. Hunam, at 790 MLK Boulevard, opened in 1980. It has long been a favorite for its Student Economy Meal Combo, as well as Cantonese-style dim sum

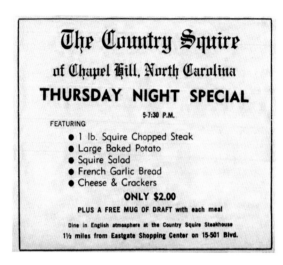

The Country Squire, which was open by 1966, was a popular steakhouse located between Chapel Hill and Durham. Unfortunately, it was later deemed to be sitting in the path of the extension of I-40 to Raleigh and forced to close in the early 1980s. This advertisement appeared in the *Daily Tar Heel* in 1969. *Courtesy Digital NC.*

on Sundays. Others that left their mark include Four-Five-Six at 118 East Franklin Street. It opened in 1982 and served Chinese food cafeteria-style for a decade. In the basement level of University Square, 35 Chinese Restaurant fed countless students at its all-you-can-eat buffet from 1996 to 2013.

Other Asian cuisines have also become popular in the Chapel Hill area. Oishii, in Timberlyne Shopping Center, has been serving sushi since 2008; Akai Hana, in Carrboro, is a dozen years older. Lime and Basil, a Vietnamese pho restaurant, opened in 2004. These are just a few examples of the Asian restaurants that have helped diversify the culinary landscape of the Chapel Hill area.

Like Chinese food, Mexican cuisine is now ubiquitous in the area but was once unknown. In the 1970s, two restaurants, Tijuana Fats and Papagayo, brought the first flavors of Mexico to Chapel Hill. Though considered Mexican restaurants, these popular establishments actually offered more of a regional cuisine from the border states that could be considered Tex-Mex or southwestern. By the 1980s, however, the options greatly increased, with more Mexican restaurants actually run by immigrants. They often featured dishes from their particular areas, such as Jalisco, like the owners of El Rodeo. That restaurant opened in 1990 in the space that had been occupied by Peking Garden, and in 2006, it moved one block east to a larger location that had been occupied by Mellow Mushroom.

In the 1990s, Chapel Hill, and Orange County as a whole, continued to grow. The changing demographic meant the arrival of culinary traditions from Latin American locations beyond Mexico. Journalist Victoria Bouloubasis, former food editor for *Indy Week*, the alternative weekly

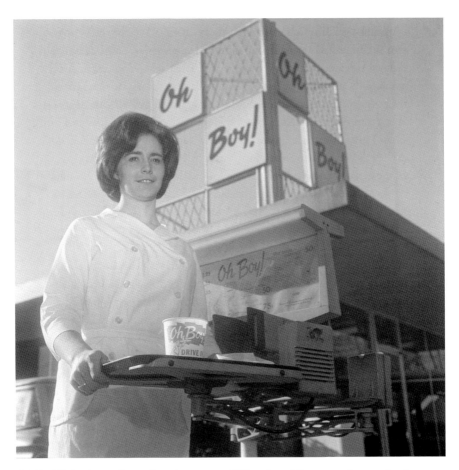

Oh Boy! Drive-in was located on the corner of Church and Rosemary Streets, the site later occupied by Colonel Chutney's. It was owned by the Boy family, which also owned the popular Blue Light restaurant in Durham. This image, from November 1964, shows waitress Carolyn Spinks. *Courtesy Roland Giduz Photographic Collection, University of North Carolina–Chapel Hill.*

newspaper of the Triangle area, recalled her days as a student at UNC. "I still dream about the *frijolada* at Patio Loco and the restaurant-turned-bar's infamous salsa nights, where people got up and danced on the bar," she said. "The vegetarian dish packed a ton of protein. I remember a few types of beans piled into a bowl, and especially crisp fresh green beans balanced on top. Fresh cilantro, a bit of crema and a homemade hot sauce rounded out this salad-type concoction. The cooks there were from different parts of Latin America, and the owner was Venezuelan. I imagine this dish was just a mashup of their individual tastes and whatever they thought could appeal to

College Café, seen here in the 1970s, was located at 115 East Franklin Street for over two decades. In the 1940s, the address had been the home of Tommy Mariakakis's Marathon Sandwich Shop. College Café moved from across the street at 126 East Franklin around 1950. By 1980, the location had been taken over by a travel agency. *Courtesy Chapel Hill Historical Society Collection, Digital NC.*

healthy-eating college kids. It worked." Patio Loco was located at 407 West Franklin Street. The building was home to Dunkin' Donuts in the 1970s and then a Chinese restaurant, the Dragon's Garden, in the 1980s.

On November 22, 1978, the restaurant industry in Chapel Hill and all of Orange County changed forever. On that day, mixed drinks were legally allowed to be served in approved establishments. Previously, North Carolina had been one of only two states (the other being Oklahoma) that still had no liquor by the drink option in restaurants.

North Carolina has always had a complicated history with alcohol. As early as the 1880s, religious and temperance groups were pushing to ban its sale in the state. They finally succeeded in 1908, when North Carolina became the first state to enact Prohibition, eleven years before the Eighteenth Amendment to the United States Constitution did so for the entire country. National Prohibition was ended in 1933, but it was not until 1935 that North Carolina followed suit. For the next thirty-seven years, only beer and wine of limited alcohol content could be served in restaurants.

Bill's Barbecue was a small take-out restaurant located at 115 North Graham Street in the 1960s and '70s. The family of Mildred "Mama Dip" Council ran it for years, and her experience there led her to open her own eatery. The location was later home to several other restaurants, including one that specialized in Jamaican cuisine. From 2004 to 2009, it was home to Queen of Sheba Ethiopian restaurant before that establishment was forced to relocate to Timberlyne Shopping Center due to real estate redevelopment on Graham Street. *Courtesy Mildred Council Papers, University of North Carolina–Chapel Hill.*

Duncan Hines, the influential restaurant reviewer in the 1930s through the 1950s, made a point of calling out the lack of liquor in his review of Chapel Hill's Carolina Inn. "Aside from this good dining room they also have a cafeteria and the kitchen is clean," he wrote. "Prices are quite reasonable. But for you liquor hounds, you better keep away—they don't serve it." The same review ran for at least a dozen years, beginning in the late 1940s. Finally, in 1967, laws were passed to allow "brown bagging." It meant a customer who wanted a mixed drink in a properly permitted restaurant could supply his own liquor (brought in a brown paper bag), and the restaurant could provide the "set-up," a glass with ice and a mixer.

By the early 1970s, the push was on to allow restaurants to actually sell liquor drinks. The North Carolina Restaurant Association promoted the passage of a liquor-by-the-drink bill, stating it would create thousands of new restaurant jobs and keep menu prices from rising. Local restaurateurs also eagerly supported the legislation for economic reasons. Mickey Ewell, owner of Spanky's and Harrison's, was the local leader of the group pushing

In the early 1960s, Elias "Leo" Eliades, who had run the grill in the Chapel Hill bus station, opened his own restaurant at 423 West Franklin Street. The location had previously been a grocery store and then Anderson's Restaurant in the 1950s. For thirty years, Leo's was known for its pizza, as well décor that included red checkered tablecloths, numerous plants and empty wine bottles. In the mid-1990s, it was replaced by Darbar Indian restaurant. The acclaimed Lantern restaurant opened in the location in 2002. *Photo by Peter Schumacher. Courtesy Durham Herald Collection, Digital NC.*

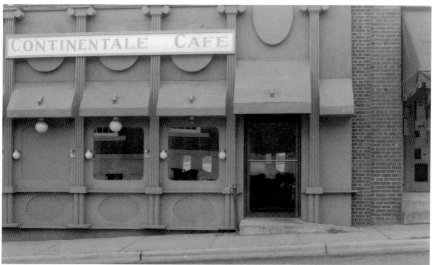

Located at 106 Henderson Street, the Continentale Café offered a menu that focused on Greek dishes but was also popular for its traditional breakfast offerings. Owned by the Lias brothers, who also owned Hector's next door, it featured a famous ceiling that was decorated with figures from Greek mythology. It operated from 1976 to 1990. *Courtesy Chapel Hill Historical Society Collection, Digital NC.*

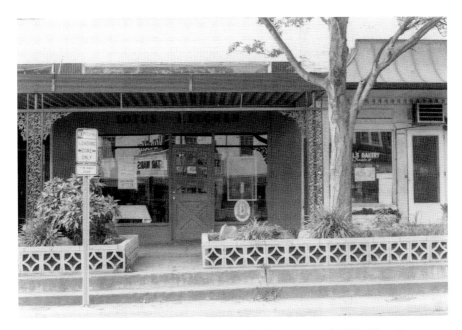

Lotus Kitchen opened at 130 East Franklin Street in the summer of 1977. (Note the reflection in the window of *Star Wars* showing at the Varsity across the street.) Ads for the new business in the *Daily Tar Heel* stated, "Now for the first time you can enjoy delicious Chinese food within walking distance of campus." Unfortunately, the restaurant did not enjoy a long existence, though its location is well known to many past and present Tar Heels—it has been the location of Johnny T-Shirt since 1983. *Courtesy Chapel Hill Historical Society Collection, Digital NC.*

for local-option voting on the issue. Dick Tabor, owner of Aurora, told the *Daily Tar Heel* that passage of the bill would bring in diners from a wider area. "If other counties don't get liquor by the drink," he said, "then they'll be coming to Chapel Hill."

Jacques Condoret, owner of Chez Condoret, a French restaurant in University Square, stated, "I think people come here for the food. But the liquor will complement it." Some restaurants even expanded in anticipation of increased business due to passage of the measure. Breadmen's 43 seats were increased to 120.

Finally, during its June session in 1978, the North Carolina General Assembly approved a local-option vote for towns and counties with an ABC store (twelve counties were dry). The first to vote was Mecklenburg County on September 8, with voters in Orange County, Southern Pines and Black Mountain going to the polls on September 12. In the end, the motion to allow liquor by the drink in Orange County passed in a 3-1 landslide.

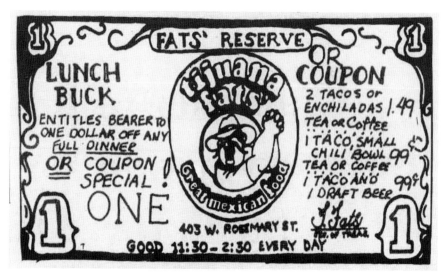

It is difficult to imagine Chapel Hill without Mexican food, but when Art Lester opened Tijuana Fats at 403 West Rosemary Street in 1970, it was likely the first restaurant in the state to serve cuisine from south of the border. Lester, who later partnered with manager Clark Church, eventually franchised the name, and other locations opened in North Carolina cities, including Greensboro and Wilmington. This coupon appeared in the *Daily Tar Heel* in 1976. *Courtesy Digital NC.*

(Mecklenburg County and Southern Pines also passed the measure, while Black Mountain did not.) The passage of another alcohol-related law twenty-seven years later also affected Chapel Hill restaurants. In August 2005, Governor Mike Easley signed into law House Bill 392. It raised the alcohol limit on beer from 6 percent to 15 percent, thus offering greater freedom as to what restaurants could serve (or brew).

Beginning in the 1980s, the emergence of chef-driven restaurants began to change the area restaurant scene. This new generation eschewed floppy white hats and stiff culinary tradition to push the limits of cooking. Led by Bill Neal and then Bill Smith, at Crook's Corner, chefs began to express their creativity by coming up with southern interpretations of European classics or focusing on fresh and locally sourced ingredients. This movement continued and expanded with later distinguished chefs including Andrea Reusing at Lantern and Brett Jennings at Elaine's.

Local chef-driven restaurants have even had affect well beyond Chapel Hill. Chefs who have trained in these restaurants have gone on to work for others or opened their own establishments elsewhere. Mondo Bistro, located at 306-D West Franklin Street, was owned by Rick Robinson, a former sous

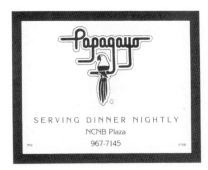

SERVING DINNER NIGHTLY
NCNB Plaza
967-7145

Papagayo opened in the back of Franklin Street's NCNB Plaza in late 1978 and featured an outdoor patio that overlooked Rosemary Street. One of the very first Mexican restaurants in town (and the very first with a mixed drink license), it offered a rather upscale dining environment, and its success soon led to the opening of other locations, including Durham and Wrightsville Beach. Dining trends eventually changed, however, and Papagayo closed in November 1997. *Collection of the author, 1988 advertisement.*

In the late 1970s, there were nearly three thousand Pizza Huts in the world. All locations followed strict brand image guidelines with regard to the buildings—all but one, that is. After nearly a year of battling town opposition, Pizza Hut opened in 1978 in the former Pure Oil gas station at 112 West Franklin Street. It had faced resistance because town leaders felt it would change the character of Franklin Street. A compromise was reached, and the restaurant moved into the renovated historic building. In 1996, it was replaced by Caribou Coffee. *Chapel Hill Historical Society Collection, University of North Carolina–Chapel Hill.*

chef at Durham's Magnolia Grill. It opened in 1993 and combined classic French cooking with seasonal and regional American flavors. The restaurant even garnered a mention in a 1995 *New York Times* article that profiled some of the exciting new restaurants in North Carolina. Unfortunately, Mondo Bistro did not have a long life; it closed in 1997, but its impact was lasting. Sous chef John Toler went on to open Raleigh's acclaimed Bloomsbury

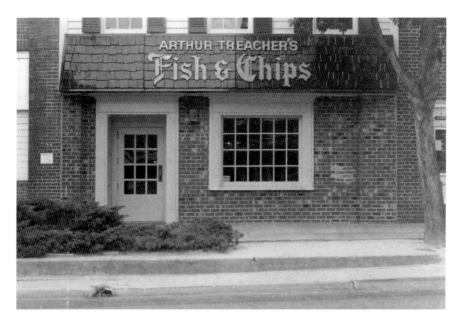

Above: More national chain restaurants moved into Chapel Hill in the 1970s. In 1976, Arthur Treacher's Fish and Chips, based in Columbus, Ohio, opened a location next to the Carolina Theater at 118 East Franklin Street. It was short-lived, however, and by 1983, the address was home to Chinese restaurant Four Five Six. *Courtesy Chapel Hill Historical Society Collection, Digital NC.*

Opposite, top: With a dress code and an upscale atmosphere, Harrison's was a new type of establishment for Chapel Hill when it opened in 1975. Harrison's success led owner Mickey Ewell to open Spanky's two years later. This advertisement appeared in the *Daily Tar Heel* in 1982. *Courtesy Digital NC.*

Opposite, bottom: Rendezvous restaurant opened in 1977 at 175 East Franklin Street. In 1978, the *Daily Tar Heel* stated it "is located in one of those buildings that just have unhappy business careers." Rendezvous was no more successful than several predecessors and, in 1979, was replaced by Four Corners Restaurant. That establishment would become a Chapel Hill institution. *Chapel Hill Historical Society Collection, Digital NC.*

Bistro, while baker Kevin Farmer earned recognition at Durham's Rue Cler. Robinson himself moved to a restaurant in Napa Valley, California, but returned several years later to launch DeeLuxe Chicken in Durham and open a Rise Biscuits and Donuts franchise in Carrboro.

An important part of dining in Chapel Hill that is often overlooked is the meal service offered by the university. For years, however, eating on campus was something that was done primarily for convenience or cost. In 1987, the *Daily Tar Heel*'s Alex Marshall wrote, "OK, so you've had a few forkfuls of

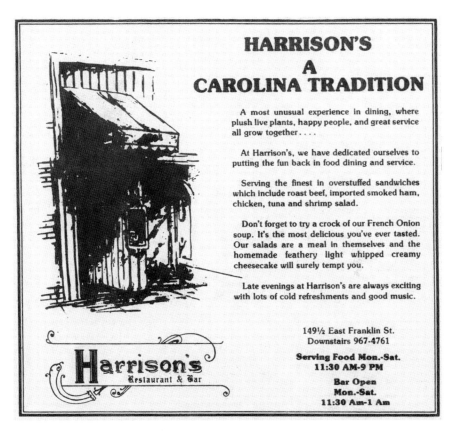

HARRISON'S
A
CAROLINA TRADITION

A most unusual experience in dining, where plush live plants, happy people, and great service all grow together. . . .

At Harrison's, we have dedicated ourselves to putting the fun back in food dining and service.

Serving the finest in overstuffed sandwiches which include roast beef, imported smoked ham, chicken, tuna and shrimp salad.

Don't forget to try a crock of our French Onion soup. It's the most delicious you've ever tasted. Our salads are a meal in themselves and the homemade feathery light whipped creamy cheesecake will surely tempt you.

Late evenings at Harrison's are always exciting with lots of cold refreshments and good music.

149½ East Franklin St.
Downstairs 967-4761

**Serving Food Mon.-Sat.
11:30 AM-9 PM**

**Bar Open
Mon.-Sat.
11:30 Am-1 Am**

Harrison's
Restaurant & Bar

Left: Harrison's, located downstairs at 149½ East Franklin Street, beneath Town and Country clothing store, opened in 1975 and closed in 1984. The address was later home to several establishments—some short-lived—including Jigsaw's, Theodore's, Franklin Street Bar and Grill, Groundhog Tavern and Goodfellow's Bar. *Courtesy Chapel Hill Historical Society Collection, University of North Carolina–Chapel Hill.*

Below: Looking Glass Café, located on the backside of University Square, facing Granville Towers, was open by 1979. For nearly two decades, it was popular for its largely vegetarian menu and live music. For several years, it was even open twenty-four hours a day, seven days a week. *Photo by Mark Dolejs. Courtesy Durham Herald Collection, Digital NC.*

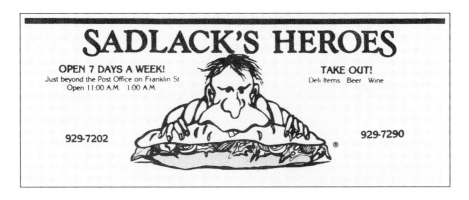

Top: The original Sadlack's Heroes began serving sub sandwiches near North Carolina State University in Raleigh in 1973. It proved very popular with college students, so Don and Diana McLennon opened the Chapel Hill location at 203 East Franklin Street in the fall of 1977. It closed in 1991. *Collection of the author.*

Bottom: Colonel Chutney's was opened in 1979 by UNC graduates Alex Porter and Brian Smith. It served a mix of traditional bar food, as well as steaks and seafood. It closed in late 1993 and was replaced by Pantana Bob's, which had other locations in Raleigh and Greenville, South Carolina. *Courtesy Chapel Hill Historical Society Collection, Digital NC.*

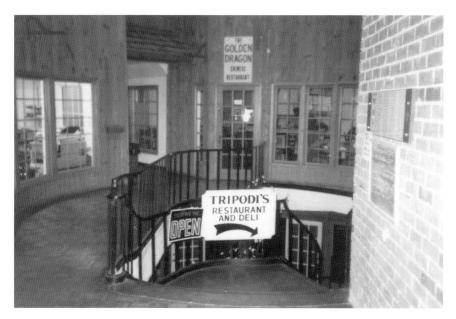

Above: Franklin Center, located at 128 East Franklin Street, has been home to several restaurants. In the 1980s, it included Golden Dragon Chinese restaurant on the main floor and Tripodi's II underground. (The first Tripodi's Delicatessen was at University Mall.) In the summer of 1999, Cosmic Cantina opened. Over twenty years later, it remains a student favorite. *Chapel Hill Historical Society Collection, Digital NC.*

Opposite, top: Serving Calabash-style fried seafood, LandLubbers opened in January 1980 at 2226 Highway 54, near the intersection with Farrington Road. It was popular with students for its affordable all-you-can-eat buffets for nearly fifteen years, until it closed in 1994. This advertisement appeared in the *Daily Tar Heel* in 1991. *Courtesy Digital NC.*

Opposite, bottom: Hotel Europa opened in 1981 on the east side of town, near where Erwin Road intersected 15-501. Its Rubens restaurant, promoted here in a 1986 advertisement, was highly regarded for many years. Another ad even proclaimed, "Rubens requires four chefs and eight veteran cooks to fulfill the promise of its gourmet menu." The hotel is now part of the Marriott chain and includes a restaurant called Carolina 1663. *Collection of the author.*

cafeteria food at Lenoir Hall, and you already find your tongue flapping in the wind and your taste buds adrift, awaiting some culinary wind to fill their sails. You need some *real* food."

Today, all food on the UNC campus is overseen by an executive chef who graduated from the Culinary Institute of America. His team includes a registered dietician, and they work to "develop well-balanced, innovative and sustainably focused menus offering local seafood, cage-free eggs, fair-trade organic coffee and teas, local produce, organic yogurt and local milk

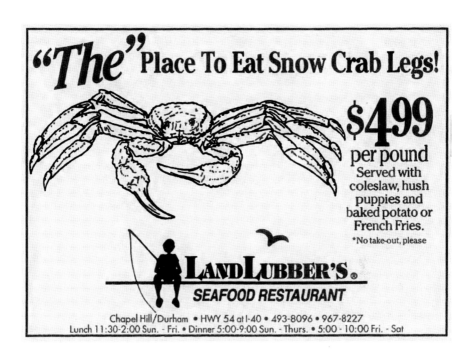
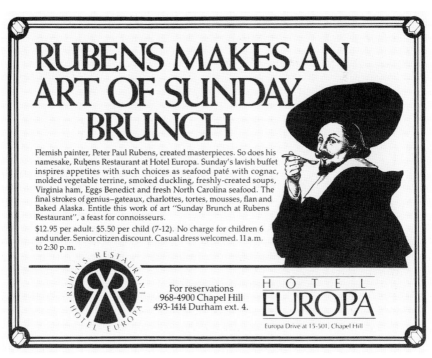
47

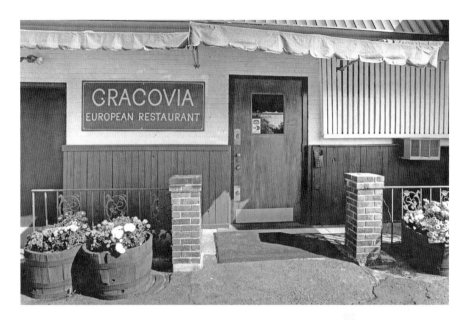

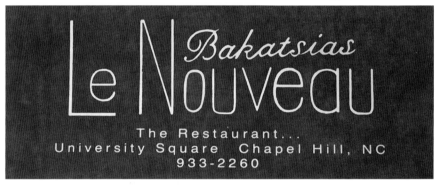

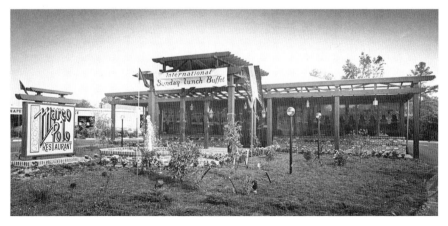

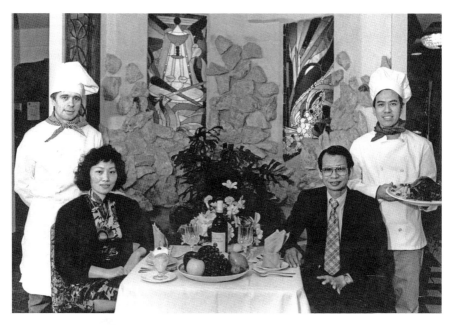

Opposite, top: In the 1980s and '90s, Cracovia was the place to go for European cuisine beyond Greek or Italian. Owners Marek Maciolowski, a UNC grad, and Margaret Szalata offered a menu that featured dishes from their native Poland, as well as Germany, France and Scandinavian. The restaurant had two locations, 300-B West Rosemary and later 220 West Rosemary. *Courtesy Durham Herald Collection, University of North Carolina–Chapel Hill.*

Opposite, middle: Since the early 1980s, Giorgios Bakatsias has played a large role in the restaurant scene in Chapel Hill, as well as neighboring Durham. In Chapel Hill, he ran Café Giorgios, a fine-dining restaurant located downstairs in University Square. It was replaced by Bakatsias Le Nouveau for several years in the 1990s. In 2003, Bakatsias opened Spice Street at University Mall. He closed it in 2013 and reopened with a new concept and name: City Kitchen. In 2013, the famed restaurateur also opened the popular Kipos Greek Taverna in the location that formerly housed Pyewacket. *Collection of the author.*

Opposite, bottom: In the late 1980s, the Chan family, owners of the Jade Palace in Carrboro, created Marco Polo, a unique restaurant that combined culinary fare of China and Italy. Located at 1813 Durham–Chapel Hill Boulevard, it even had two chefs, one who specialized in each type of cuisine. In the late 1990s, the location became home to La Hacienda Mexican restaurant. *Photo by Jim Thornton. Courtesy Durham Herald Collection, University of North Carolina–Chapel Hill.*

Above: Marco Polo owners Jenny and Francis Chan with Italian chef Giovanni (*left*) and Chinese chef Chan in 1991. *Courtesy Durham Herald Collection, University of North Carolina–Chapel Hill.*

Left: Hardback Café, located in the building that had once housed Linda's Bar and Grill, was opened in 1985 by Grant Kornberg. An important literary and music hangout, which also served burgers and beer, for a decade, it closed in 1994. After it was gone, people covered the windows with colored paper on which they had written their goodbyes. *Collection of the author, 1986 advertisement.*

Below: Passage to India opened in 1989 in the basement level of the Professional Building at 1301 East Franklin Street, a location that had previously been occupied by an eatery named the Brass Rail. Over thirty years later, the site is still serving Indian cuisine, though it has transformed into Tandoor Indian Restaurant. *Photo by Biar Orrell. Courtesy Durham Herald Collection, University of North Carolina–Chapel Hill.*

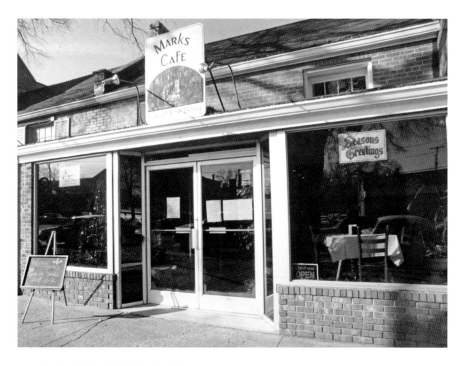

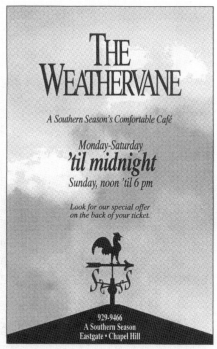

Above: Like most addresses on Franklin Street, 454 West has been home to numerous businesses, including Aurora Restaurant, Sunshine Café, Mark's Café (seen here in 1991) and Fusions New World Cuisine. Since 1999, it has been occupied by Elaine's On Franklin, one of Chapel Hill's most highly acclaimed dining establishments. *Photo by Anitta Frazier. Courtesy Durham Herald Collection, University of North Carolina–Chapel Hill.*

Left: A Southern Season began in the 1970s as a small coffee roastery and gourmet grocery store. It soon moved across Eastgate Shopping Center to a larger space (occupied by Trader Joe's today). There, Weathervane Café opened. In 2003, the store moved again, this time to University Mall, and took over the space previously occupied by Belk's. Weathervane reopened in a much larger space with an outdoor terrace and was especially popular for weekend brunch. Both the store and restaurant closed in 2019. *Collection of the author.*

51

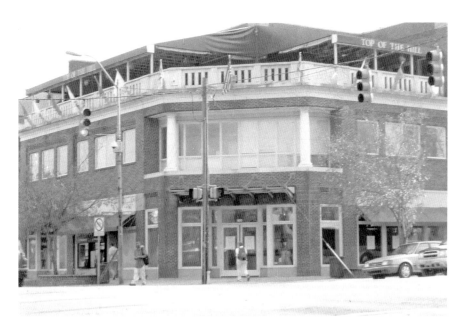

Top of the Hill, a brewery and restaurant, has presided over Chapel Hill's main crossroads for well over two decades. Originally the site of a Texaco station, it later became the Happy Store, a gas station and—perhaps more importantly—a popular place for students to purchase beer. In 1994, Scott Maitland, a UNC law student at the time, heard that a national chain restaurant was going to take over the space, so he developed plans for his own restaurant. Top of the Hill opened in 1996 and soon became immensely popular for both its food and beer. Its success eventually led to the creation of a sister business on Franklin Street, TOPO Organic Spirits Distillery, which opened in 2012. *Courtesy Chapel Hill Historical Society Collection, Digital NC.*

products." With everything from sushi to an omelet bar to vegetarian specials, the offerings at Lenoir and Chase dining halls have change immensely since the early 2000s.

This is great news for students, but for restaurants on Franklin Street, it brings added competition. Once upon a time, they could count on the patronage of students seeking an alternative to boring campus food. That is no longer the case. Some well-known local restaurants, including Mediterranean Deli, Italian Pizzeria III and Merritt's, have established outlets in Lenoir Hall, but for many, that is not possible. No matter how it is viewed, there is no denying that the evolution of Carolina Dining Services has played a role in the Chapel Hill restaurant story.

Today, the dining options in Orange County are amazingly diverse for an area its size, and the choices are almost overwhelming. Just selecting a type of cuisine—be it Mexican, Indian, Middle Eastern, Italian, Asian and so

forth—presents multiple restaurant options. Want something as simple as a burger? Again, the choices for a fresh-made, non–fast food burger are many.

Restaurants are spread across the towns of the county, but even for students lacking transportation, the options adjacent to campus on Franklin Street alone can be mind-boggling. These options show just how much the restaurant industry of Chapel Hill has evolved over the years. And that change will continue. New eateries will open, some to close quickly, and some to thrive for years. Through it all, Chapel Hill will remain a culinary destination.

2
Chapel Hill Icons

There is no way to rate restaurants of the so many different types that have existed in Chapel Hill and certainly no way to review ones that are long gone. However, their importance to the town can be judged by contemporary news articles and the memories of people who dined in them. Almost without exception, this section contains restaurants that have been, or were, in existence for at least twenty years. They have all played their parts in shaping the Chapel Hill culinary scene into what it is today.

411 WEST

411 West Franklin Street

When 411 West first opened, I was in my twenties, and it quickly became my favorite "fancy" place to eat in town. Which meant my then boyfriend and I only got to eat there when our parents were paying or on special occasion. Over the years, we got older and more able to pay the tab ourselves (although not always: my father-in-law Earl had his own bar stool there and never let anyone pick up a check). Now, thirty years later, it's my twelve-year-old daughter's favorite place to eat in town. For me, the margarita pizza, classic Caesar and lemon linguine at 411 are all comfort food. No matter how much else changes, as a local you feel at home when you eat there.

—Sarah Dessen

Recognizing the growing influence of California cuisine, Mickey Ewell and his Chapel Hill Restaurant Group decided that a restaurant that served creative thin-crust pizzas made in an authentic Italian wood-burning pizza oven and fresh pastas made in house would be ideal for Chapel Hill. For their new venture, they chose a building at 411 West Franklin Street that had, for years, been home to Hollywood Restaurant and Cab Company and later the Bread Shop. The building's address became the new name of the restaurant, and it opened in 1990.

Soon one of the most popular restaurants in Chapel Hill, 411 West even garnered attention outside of the local area when *Southern Living* proclaimed, "411 West has brought Italy to North Carolina." The *Wine Spectator* also recognized the restaurant for its wine list. More locally, readers of area publication *Indy Week* voted 411 West Best Italian Restaurant in the Triangle eight times, and *Chapel Hill Magazine* has named it Best Italian Restaurant in Chapel Hill every year since beginning its awards in 2012.

ALLEN & SON

6203 Millhouse Road

Most North Carolina towns have a destination for pork barbecue, but few can claim one as prestigious as Allen & Son. Keith Allen, who opened the restaurant at the age of only nineteen, is actually the son in Allen & Son. His father, James Allen, bought a barbecue restaurant on 15-501 in Bynum, south of Chapel Hill, in the 1960s. It was there that the younger Allen learned the art of slow-cooking barbecue with wood.

In 1971, Keith Allen came across a restaurant for sale a few miles north of Chapel Hill on Highway 86. He quit his job as a butcher at the A&P, borrowed $3,000 and bought the establishment. Allen slowly built a following for his hickory-smoked pork (he reportedly went through a cord of wood per day) and rose to the status of royalty in the barbecue world. Connoisseurs from across the country made a pilgrimage to the old cinderblock building next to the railroad tracks to taste Allen's hickory-smoked shoulders served with vinegar-based sauce. There, beneath walls covered with hunting and fishing trophies and numerous awards for barbecue, they dined at tables covered in green checkered tablecloths. And not only was the eatery known for its pork, but its desserts—particularly pecan pie and banana pudding—were nearly

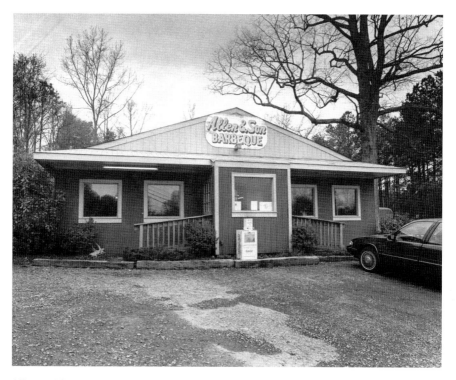

Allen and Son barbecue in 1991. *Photo by Jim Thornton. Courtesy Durham Herald Collection, University of North Carolina–Chapel Hill.*

just as famous. Allen and his staff made them and the ice cream fresh every day. Allen & Son became so well known that celebrities Martha Stewart and Rachael Ray featured the fare on television, and Allen was the subject of an article in the *Los Angeles Times* in 2007.

After forty-seven years of rising in the middle of the night to start the wood fires, Keith Allen decided to retire. He closed his restaurant in December 2018, not long after it had been named no. 5 in the South's Top 50 Barbecue Joints 2018 by *Southern Living*. Such a distinguished eatery could not close quietly, however, and Allen & Son's demise led to articles in *Southern Living*, Raleigh's *News and Observer* and other publications. (The original Bynum location of Allen & Son is still in operation, though it was taken over by a different operator under a licensing agreement after James Allen died.)

BRADY'S RESTAURANT

1505 E. Franklin St.

My aunt Grace waited tables at Brady's in the 1950s. She doted on the college students that came in and gave them extra food. That's how she knew people like Tar Heel baseball star Jim Raugh. She helped me meet him and get a signed baseball. That was a good family restaurant. Great fish, barbecue and Brunswick stew.

—Mike Knowles

In 1941, Brady McLennan, who had graduated from UNC in 1929, opened his self-named restaurant on the eastern edge of town. For over forty years, it served the traditional southern staples, with the pork chops being particularly famed. Brady's was a popular destination for students who had the vehicular means (or at least a friend who did so) to make it

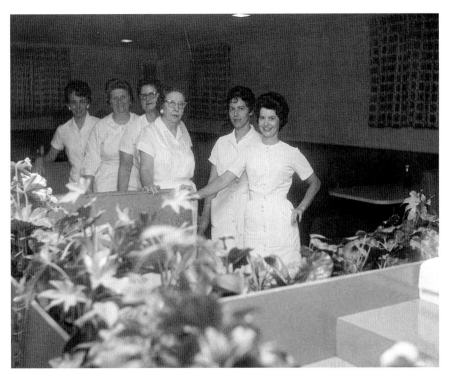

Members of Brady's waitstaff in the early 1960s. *Courtesy Roland Giduz Photographic Collection, University of North Carolina–Chapel Hill.*

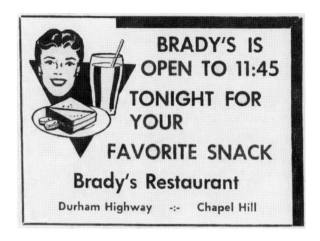

Brady's was popular with students and town residents alike for over forty years. *Collection of the author.*

"one mile out Durham Highway," as ads stated. In early years, the business also included a small grocery store and gas pumps in addition to two dining rooms. By the 1980s, the town had greatly expanded in the direction of Brady's, and commercial property values skyrocketed. In addition, Brady himself died in 1984, so the restaurant was sold and torn down. It was replaced by the Siena Hotel.

BREADMEN'S

337 West Rosemary Street/324 West Rosemary Street

When any UNC student thinks of breakfast, the first word that often comes to mind is Breadmen's—and not just for the first meal of the day. Breadmen's has been serving biscuits, omelets and pancakes all day since 1974. Of course, it does serve a full menu that includes burgers, sandwiches and barbecue, but it is breakfast that has made Breadmen's famous.

In a former Burger Chef location on the south side of West Rosemary Street, UNC graduate Roy Piscitello opened Breadmen's. He was soon joined by his brother Bill, and the two helped turn the restaurant into one of the town's most celebrated dining destinations. In 1992, a larger space across the street that had been occupied by Western Sizzlin' became available, and the Piscitellos relocated. Nearly thirty years later, Breadmen's remains one of Chapel Hill's most-loved eateries.

CAROLINA BREWERY

460 West Franklin Street

In the mid 1990s. I was hired as the restaurant/menu consultant for the Carolina Brewery. We started out with the goal of having the best burger in Chapel Hill and then gradually expand.

Everything was from scratch. We cut our own fries, got fresh seafood from Tom Robinson and meat from Cliff's in Carrboro.

A year after we opened, we helped host a microbrew expo in Durham, and the renowned English beer/spirits author Michael Jackson was one of the judges and guest speakers. During it, the owners of Carolina Brewery approached Michael and arranged for him to visit the brewery and have lunch. We proudly served him that day, and he was very engaging. I remember at the table with us were a dozen people including Bob Poitras, the principle investor; his son Robert; Chris Rice, who was also an original owner; and Jon Connolly, the brewer. At the end of the meal, Bob broke out some cigars (you could smoke in restaurants then) and a rare vintage scotch whiskey. As we enjoyed our whiskey and smokes, Michael held up his glass, while studying the liquor, and proclaimed in his thick brogue, "that's a mighty fine breakfast whiskey." That's when I realized I was not worthy! I still have the note he wrote saying how much he enjoyed the food.

—Mel Melton

Though known across the state and beyond for its beer, Chapel Hill's first brewery has also been home to a distinguished restaurant for over twenty-five years. On a trip to Europe, UNC students Robert Poitras and Chris Rice became interested in brewing. They wrote a business plan that merged a craft brewery with a restaurant and, after graduation, worked to make it a reality. They soon found a large enough location on West Franklin Street that for years had been a furniture showroom. The two-story space had recently been turned into a new location for Mast General Store, a chain based in the mountains. It had struggled in the Chapel Hill market, though, and the owners wanted to sell the building. Poitras and Rice bought it, and Carolina Brewery opened in 1995.

Competition has certainly increased in the brewery and brewpub world in the years since it opened, but Carolina Brewery has remained successful by offering food that matches the quality of its beer. Its large bar area also makes it a popular destination for viewing UNC sporting

events on television. In 2007, Carolina Brewery expanded and opened a second location with a larger brewing operation and another restaurant in Pittsboro.

CAROLINA COFFEE SHOP

138 East Franklin Street

In 1970, one of the guys in my band got a job at Carolina Coffee Shop washing dishes. It wasn't long before the whole band was essentially the dish washing crew. And back in those days, there were no dishwashing machines, everything was done in a three-compartment sink. There were always two of us working at it.

Byron was a damn nice guy, and he even offered me the opportunity to cook. But I saw how hard those guys worked and was happy to just wash dishes at the time. Overall, it was quite the educational experience, since I had never worked in any restaurant before. Little did I know my long career in restaurants was beginning right there as a Carolina Coffee Shop dishwasher.

—*Mel Melton*

Of all of Chapel Hill's restaurants, one has a claim to fame grander than all the rest: Carolina Coffee Shop is the oldest continually running restaurant in North Carolina. For nearly a century, as of this writing, it has been a student tradition, as well as a required place to visit for generations of returning alumni.

In a building that once housed a student post office, Carolina Confectionary opened in 1922. It served candy, sodas and sandwiches. In 1928, George Livas and James Gust purchased the establishment and renamed it the Carolina Coffee Shop. Livas continued to run it until his death in 1956. Another local restaurateur then ran the business for a couple of years before Byron Freeman took over. He went on to operate it for more than forty years before selling to Greg Owens. In 2018, a group of UNC graduates, including Olympic soccer star Heather O'Reilly, took over ownership. "It's in such a great location here on Franklin Street and I think that when you close your eyes and imagine Franklin Street, you imagine it with a Carolina Coffee Shop," O'Reilly told the *Daily Tar Heel*.

During These Hot Spring Days—

Keep yourself cool with a soothing milk shake
and a delicious sandwich

Carolina Confectionary Co.

A Matter of Preference

The Owl Shop

is preferred by those who desire prompt
attention and good food well cooked.

TRY OUR

"BLUE PLATE" DINNER

And you, also, will prefer

THE OWL

Sandwich & Waffle Shop

Left: This advertisement for Carolina Confectionary, the original name of Carolina Coffee Shop, appeared in the *Daily Tar Heel* in 1926. The business promoted below it, the Owl Sandwich and Waffle Shop, served customers at an unknown location. It appeared in several mid-1920s advertisements, but the address was only ever given as Franklin Street. *Courtesy Digital NC.*

Below: A 1946 advertisement for the Carolina Coffee Shop from the *Daily Tar Heel. Courtesy Digital NC.*

Drop in at the

CAROLINA COFFEE SHOP

Before the Dances

Right: A 1983 advertisement for the Carolina Coffee Shop. *Collection of the author.*

Below: Carolina Coffee Shop in the 1980s. *Photo by Jim Sparks. Courtesy Durham Herald Collection, University of North Carolina–Chapel Hill.*

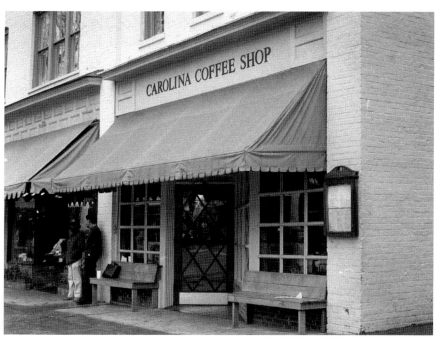

"I have that etched in my mind as a staple of the town and the street." Serving what it describes as "southern food with a modern twist," Carolina Coffee Shop remains an integral part of the Chapel Hill experience for both students and visitors.

CAROLINA INN

211 Pittsboro Street

On visiting UNC in the early 1920s, a member of the board of trustees, wealthy alumnus John Sprunt Hill, realized that there was a lack of accommodations for visitors. He decided to purchase land next to the university and hired award-winning architect Arthur Nash (designer of Wilson Library) to build a hotel. The result was the Carolina Inn, which opened in 1924. As a gift, Hill gave the inn to the university in 1935, with the stipulation that all profits were to be used to support the university's library. (Contributions today help support the North Carolina Collection). In the nearly one hundred years since opening, the Carolina Inn has become arguably the most famous building in town and was even called the "university's living room" by UNC president William Friday.

Though primarily constructed for lodging, the Carolina Inn has always offered dining. For years, it had an inexpensive cafeteria, which was staffed by students, and a more formal dining room. An expansion in the 1960s brought a new cafeteria, but a mid-1990s renovation led

A 1994 advertisement for Hill Room at the Carolina Inn. *Collection of the author.*

Above: Cracovia, which opened in 1984, specialized in Polish and European cuisine at its Rosemary Street location. It closed in 1995. *Matchbook from collection of the author.*

Right: A 1980s matchbook for Four Five Six, which also had a location in Raleigh directly across from North Carolina State University. *Collection of the author.*

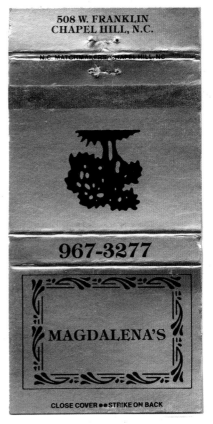

Left: Mariakakis was a Chapel Hill favorite for over thirty years before converting into a specialty food and wine store. *Collection of the author.*

Right: Magdalena's, which served southwestern/Mexican cuisine, was opened in 1983 by Phil and Vickie Campbell and Larry Nahmias. The Campbells later left to start Flying Burrito. In the late 1980s, Magdalena's was known for its upstairs La Terraza live music venue, which brought in nationally known acts, particularly in the blues genre. It closed in 1990. *Collection of the author.*

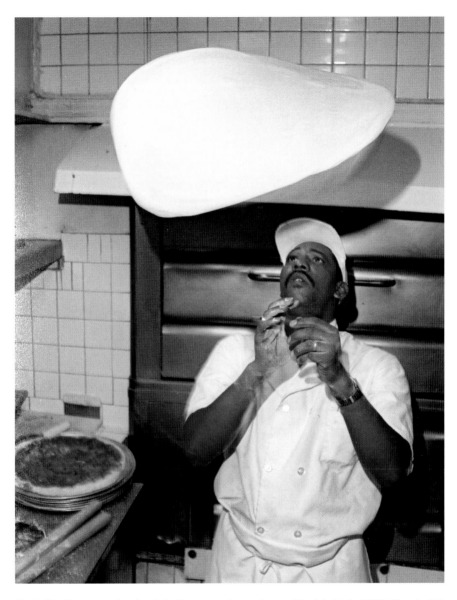

Craig Fletcher tosses the dough before preparing a pizza at Mariakakis in 1993. *Photo by Bill Willcox. Courtesy Durham Herald Collection, University of North Carolina–Chapel Hill.*

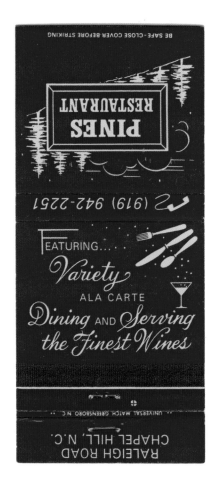

Left: A 1950s matchbook promoting the Pines restaurant. *Collection of the author.*

Below: This circa 1970 postcard shows the Pines restaurant (*bottom left*). It was essentially part of the University Motor Inn complex. *Collection of the author.*

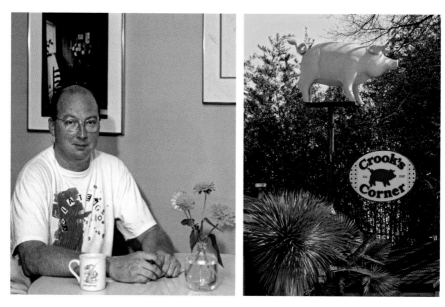

Left: Legendary Crook's Corner chef Bill Smith in 1992. *Photo by Biar Orrel. Courtesy* Durham Herald *Collection, University of North Carolina–Chapel Hill.*

Right: Crook's Corner sign. *Photo by Chris Holaday.*

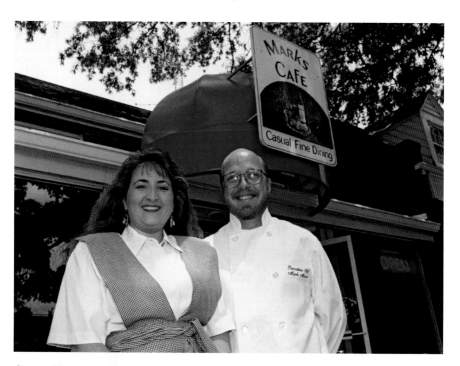

Owners Nancy and Mark Moore in front of Mark's Café in 1994. The restaurant specialized in seafood for several years in the early 1990s. *Photo by Peter Schumacher. Courtesy* Durham Herald *Collection, University of North Carolina–Chapel Hill.*

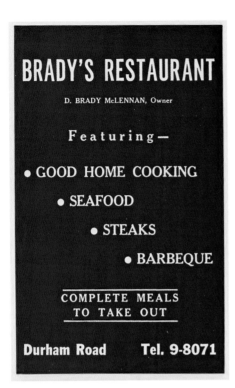

BRADY'S RESTAURANT

D. BRADY McLENNAN, Owner

Featuring—

- GOOD HOME COOKING
- SEAFOOD
- STEAKS
- BARBEQUE

COMPLETE MEALS
TO TAKE OUT

Durham Road **Tel. 9-8071**

Left: A Brady's advertisement from *Hill's 1957 Chapel Hill City Guide*. *Courtesy Digital NC.*

Below: Pete Dorrance (*left*) and Greg Overbeck, two of the four partners who made up Chapel Hill Restaurant Group in the 1980s. *Photo by Jim Thornton. Courtesy* Durham Herald *Collection, University of North Carolina–Chapel Hill.*

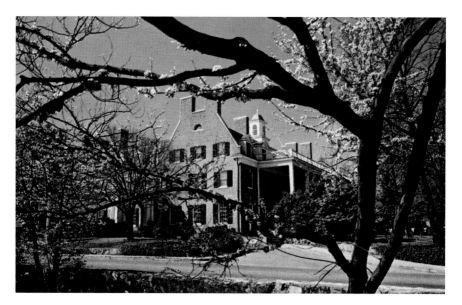

Carolina Inn postcard. *Courtesy Durwood Barbour Postcard Collection, University of North Carolina–Chapel Hill.*

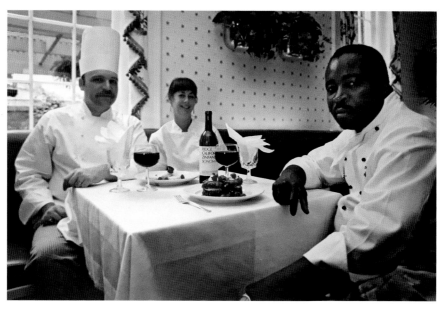

The kitchen staff of the Carolina Inn in 1993 included sous chef Terry Stafford, lead baker Betsy Munson and executive chef Morris Sherman. *Photo by Walt Unks. Courtesy Durham Herald Collection, University of North Carolina–Chapel Hill.*

Four Corners bartenders Jenni Bagwell and Susan Thorsland with manager Craig Reed in 1993. *Photo by Biar Orrell. Courtesy Durham Herald Collection, University of North Carolina–Chapel Hill.*

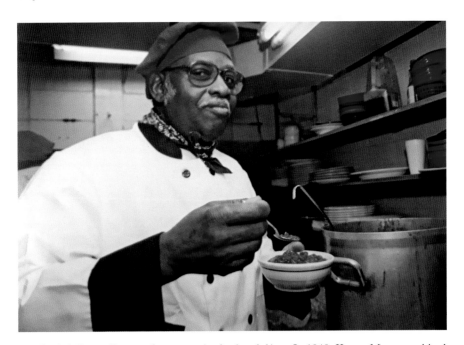

The Rathskeller staff was as famous as the food and décor. In 1949, Kenny Mann was hired as a cook. He eventually became the restaurant's chef, a position he held until retirement in 2003. Here he shows off his chili, the winner in the cook-off during Festifall in 1994. *Photo by Biar Orrell. Courtesy Durham Herald Collection, University of North Carolina–Chapel Hill.*

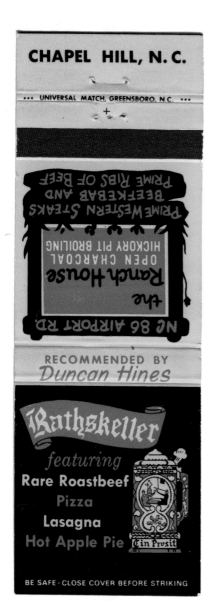

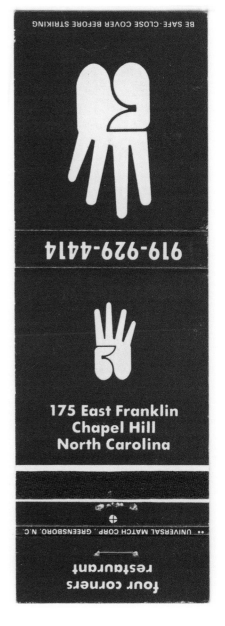

Above: A 1960s matchbook promoting two Danziger's restaurants, Rathskeller and the Ranch House. *Collection of the author.*

Right: A Four Corners matchbook, circa 1980s. *Collection of the author.*

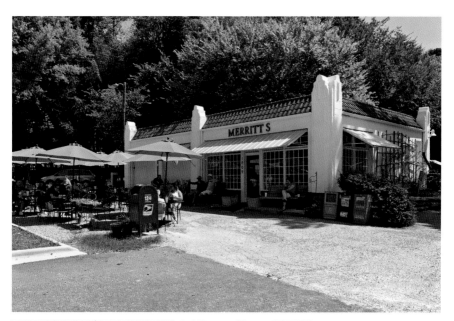

Above: The food at Merritt's Store is always popular, but at the peak of tomato season in the summer, the tables are packed and wait times are long for a legendary BLT sandwich. *Photo by Chris Holaday.*

Left: Chef Devon Mills of La Résidence in 1994. Mills had previously worked at 411 West and Durham's Magnolia Grill. He later became the chef at Southern Season's Weathervane restaurant before opening his own eatery, Babette's, in Durham. *Photo by Mark Dolejs. Courtesy Durham Herald Collection, University of North Carolina–Chapel Hill.*

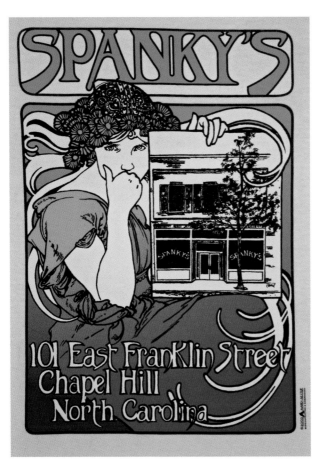

101 East Franklin Street
Chapel Hill
North Carolina

Left: Spanky's well-known logo. *Courtesy Greg Overbeck/Chapel Hill Restaurant Group.*

Below: Spanky's entrance. *Courtesy Greg Overbeck/Chapel Hill Restaurant Group.*

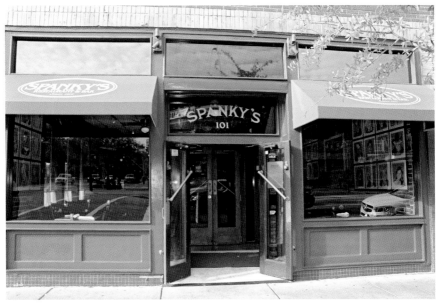

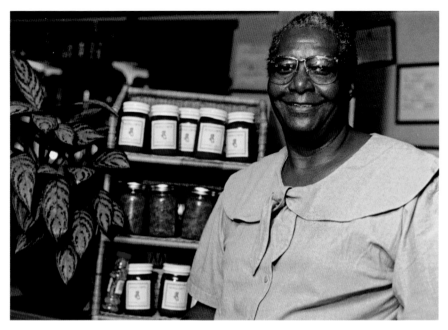

Mildred "Mama Dip" Council in 1992. *Photo by Biar Orrell. Courtesy Durham Herald Collection, University of North Carolina–Chapel Hill.*

Mama Dip's first location, 405 West Rosemary Street. *Mildred Council Papers, University of North Carolina–Chapel Hill.*

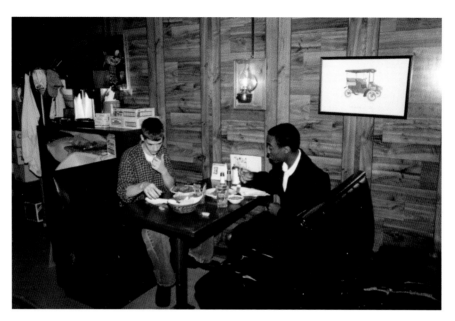

Two customers enjoy a meal inside the original location of Mama Dip's. *Mildred Council Papers, University of North Carolina–Chapel Hill.*

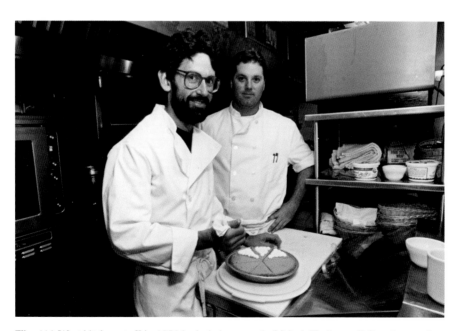

The 411 West kitchen staff in 1991 included pastry chef Mark Tachman (*left*) and executive chef Trey Cleveland. Tachman has been the pastry chef at 411 since 1990. Cleveland took over as executive chef of Top of the Hill in 2000. *Photo by Chuck Liddy. Courtesy* Durham Herald *Collection, University of North Carolina–Chapel Hill.*

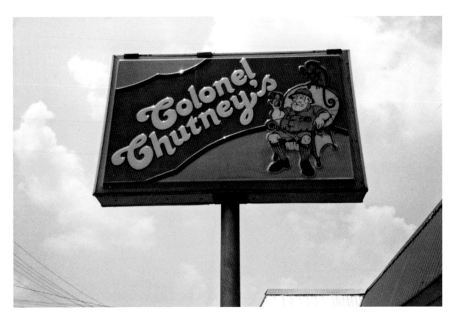

Colonel Chutney's, which featured a large outdoor patio, was located at 300 West Rosemary Street for over fourteen years. Popular as a restaurant, it was perhaps more famous as the place to go on Sunday nights for drink specials. *Courtesy Chapel Hill Historical Society Collection, University of North Carolina–Chapel Hill.*

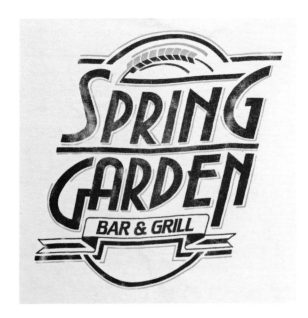

Located across the street from Weaver Street Market, Spring Garden Bar and Grill featured a unique triangle-shaped bar that fit the shape of the building. The bar was retained by Spotted Dog when it opened in 1998. *Collection of the author.*

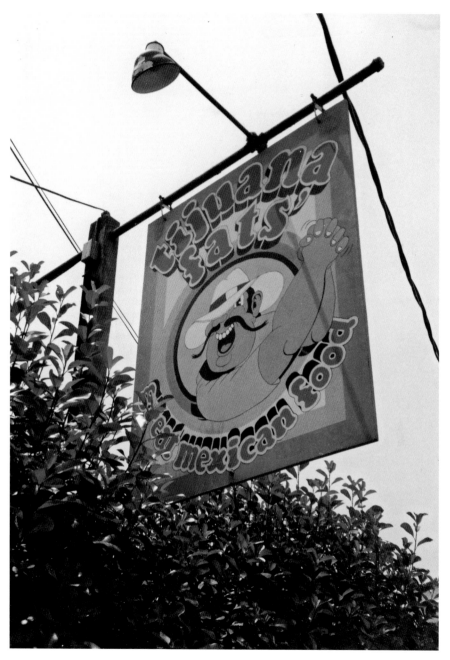

From 1970 until 1993, the Tijuana Fats sign at 403 West Rosemary Street showed the way to the town's first Mexican restaurant. The location was later home to Henry's Bistro. *Courtesy Chapel Hill Historical Society Collection, University of North Carolina–Chapel Hill.*

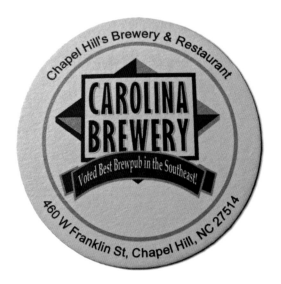

Though it is primarily thought of for its award-winning beers, Carolina Brewery has put an equal emphasis on having a creative restaurant since the beginning. *Collection of the author.*

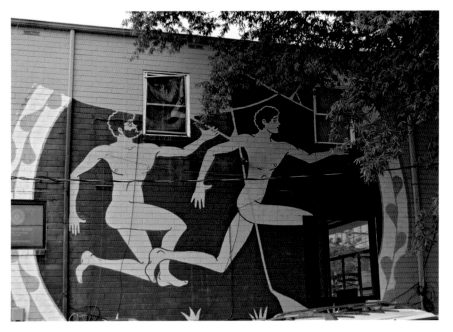

Marathon Restaurant, at 708 West Rosemary in Carrboro, may be long gone, but the well-known mural on its wall remains one of the most familiar in town. The eatery existed from the mid-1980s to mid-1990s and also offered delivery. It served pizza and Greek sandwiches, but its steak and cheese was the most popular. *Photo by Chris Holaday.*

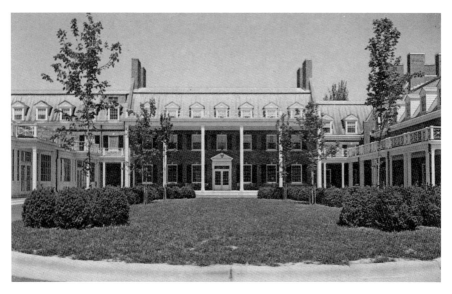

A vintage postcard featuring the Carolina Inn. *Courtesy Durwood Barbour Postcard Collection, University of North Carolina–Chapel Hill.*

to its closure. Since then, the food focus of the inn has been on fine dining. The Crossroads Restaurant is regarded as one of the most prestigious in the state and has won a AAA Four Diamond award, a *Wine Spectator* Award of Excellence, a Mobil Four Star Award and is one of only three restaurants in North Carolina to be given a Forbes Four Star Service Award.

COLONIAL DRUG STORE

450 West Franklin Street

Opened in 1951, Colonial Drug Store featured a lunch counter and booths like many pharmacies of the era. That lunch counter became famous for two things: being the site of civil rights protests in the early 1960s and the Big O, a popular orange beverage served for decades.

In the Jim Crow era, Black customers could be served at the counter but were not allowed to sit down. On February 28, 1960, nine students from nearby Lincoln High School, a school for Black students, made Colonial Drug the site of Chapel Hill's first sit-in. In a 2020 interview, Jim Merritt, one of the original protesters, told chapelboro.com, "This establishment

was owned by a proprietor who lived in the black neighborhood. It was disappointing when he wouldn't allow us to sit down because we grew up with him being in the neighborhood." Those nine protestors are now honored by a monument outside the location.

After desegregation, the fame of the Colonial Drug Store's lunch counter revolved around its beverage made with real oranges, a secret homemade syrup, water and ice. "The Home of the Big O" was even emblazoned across the front window. After forty-five years in business, Colonial Drug closed in 1996, and the location became home to the West End Wine Bar.

COSMIC CANTINA

128 East Franklin Street

One of my college gigs was working the cash register at Cosmic Cantina during lunch rush. Working there helped me learn Spanish really quick, and I got to skip the line during the 3 a.m. madness.

—*Victoria Bouloubasis*

The original Cosmic Cantina opened within walking distance of Duke's East Campus in 1995. It offered large California-style burritos filled with fresh, organic ingredients, along with beer and margaritas. Perhaps most important to students, the Cosmic Cantina's prices were low, and the establishment remained open until 4:00 a.m. It proved successful, and in 1999, owner Cosmos Lyles decided to open a second location in Chapel Hill to serve University of North Carolina students. It has remained a popular lunch and late-night destination for over two decades.

CROOK'S CORNER

610 West Franklin Street

When I moved to Chapel Hill in 2003, I was excited to dine at the iconic Crook's Corner after hearing the buzz and passing by the pig statue on top of the building on Franklin Street. The first time I ate there I was

seated on the patio. The weather was perfect, and the twinkling white lights overhead set the perfect mood. I ordered the Tabasco chicken, and it was divine. Pleasingly spicy and served on a bed of perfectly mashed potatoes with a side of wilted spinach. I ran the cooking school at A Southern Season, and I tasked myself to replicate that chicken. I spent many meals in that dining room—which reminded me of a New York City eatery with small tables close together filled with happy eaters—but one meal at Crook's was particularly memorable. I ordered fried oysters and a salad at the bar, and my dear friend and longtime chef at Crook's, Bill Smith, perfectly cooked the oysters himself and came out to the bar. We had a wonderful conversation while I enjoyed my meal.

—Marilyn Markel

My son Josh and I went to dinner almost every Sunday at Crooks. Hal and I went a lot, too, and we happened to be there having dinner one time in the middle of the summer when Bill Smith emerged from the kitchen looking kind of all wild and crazy. He walked over and said, "Taste this." He had just invented honeysuckle sorbet. He had apparently gotten up in the night to pick it and work on it and was just bringing it for the first time. I will never forget. He looked crazy since he'd been up since who knows when. It was delicious but a lot of work. I think he did it only once a year after that.

—Lee Smith

Any discussion of Chapel Hill restaurants likely begins with Crook's Corner. Probably the town's most famous eating establishment, Crook's has been at the forefront of southern cuisine for nearly four decades. It has been the subject of numerous national articles and was named an American Classic by the James Beard Foundation, meaning that Crook's has "timeless appeal, beloved for quality of food that reflects the character of their community." Despite that honor, Crook's may be more famous for its folk-art animal sculptures, hubcap collection, garden, pig sign or as the birthplace of shrimp and grits.

The eclectically decorated building that houses Crook's began its existence as a service station in the 1920s. After World War II, it became Rachel Crook's Fish and Produce Market. Unfortunately, the owner of that business was the victim of an infamous 1951 murder that remains unsolved. In later years, the site was home to several business, including two other produce stands (Blackburn's and Melton's), and in the late

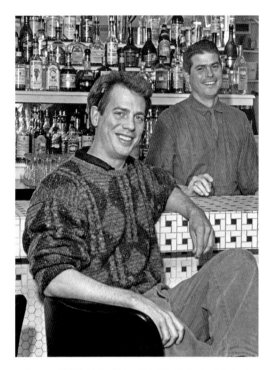

Left: Bill Neal (*left*) and Gene Hamer, the founders of Crook's Corner. *Photo by Chuck Liddy. Courtesy Durham Herald Collection, University of North Carolina–Chapel Hill.*

Below: A 1983 advertisement for Crook's Corner. *Collection of the author.*

CROOK'S CORNER

Carolina Shrimp Boil, Soft Crabs with Basil Butter,
Mussels Mariniere, Chicken Country Captain,
Grilled Veal Chops with fresh Rosemary, Peach Cobbler,
Homestyle Pizza, Baked Artichokes with Goat Cheese,
Blueberry Pie, Fresh Pasta, Caramel Cake
with Toasted Pecans

Just a few of the reasons **Food and Wine** magazine
selected Crook's as one of the 60 best American restaurants
in 1983.

LUNCH: Monday-Saturday
DINNER: every night
Late night menu and Juke Box music until 11:30

610 WEST FRANKLIN ST., CHAPEL HILL

1970s, it became an extension of a used car dealership, which was located across the street. Finally, it became a barbecue joint, which in 1982, Bill Neal and Gene Hamer decided to purchase to transform into a new restaurant that focused on southern cuisine. Named Crook's Corner, it was soon drawing attention for its interpretation of regional dishes (for example, Neal taking something as simple as grits and adding shrimp). In 1985, a visit by *New York Times* food critic Craig Claiborne helped the restaurant's star rise even higher.

Bill Neal furthered Crook's fame with several acclaimed cookbooks, including *Southern Cooking* and *Biscuits, Spoonbread and Sweet Potato Pie*. Bill Smith followed as chef after Neal's untimely death in 1991 and built on the Crook's legacy. He also authored cookbooks (*Seasoned in the South* and *Crabs & Oysters*) and was recognized by the James Beard Foundation as a finalist for Best Chef Southeast in 2009 and 2010.

A new era began at Crook's in 2019; Bill Smith retired at the beginning of the year, and Gene Hamer decided to sell the iconic restaurant. It was purchased by Gary Crunkleton, owner of the Crunkleton bar in Chapel Hill, and Crook's former bar manager Shannon Healy, owner of Alley Twenty Six bar and restaurant in Durham. The new owners brought in chef Justin Burdett, who had been running his own acclaimed restaurant in Asheville, to keep Crook's at the forefront of creative southern cuisine.

ELAINE'S ON FRANKLIN

454 West Franklin Street

In 1999, chef Brett Jennings, who had trained with renowned chef Ben Barker at Magnolia Grill in Durham and in Europe, decided to open his own restaurant. Featuring a farm-to-fork menu, Elaine's soon became regarded as one of the top dining destinations in Chapel Hill, while Jennings has been acclaimed as one of the top chefs in the Triangle area. Not only has the food brought praise to Elaine's, but it has also received the *Wine Spectator* Award of Excellence multiple times for its wine list.

FARM HOUSE RESTAURANT

6004 Milhouse Road

A trip to the Farm House Restaurant is almost like a trip back in time. North of town down a gravel road beside the railroad tracks and seemingly deep in the woods, it has been open since 1969. The photos of notable diners lining the walls of the entryway attest to the popularity it has enjoyed over the years. This dinner-only unpretentious restaurant is all about steak (and potatoes). Various cuts of meat are cooked on the open charcoal grill and delivered to the table on sizzling hot cast-iron skillets. Once upon a time, rustic and old-fashioned steakhouses such as the Ranch House and the Country Squire were very popular. The others are all gone now, but the Farm House remains.

FLYING BURRITO

746 Airport Road/Martin Luther King Jr. Boulevard

Phil Campbell was a real original and really a good cook. He was also so into baseball, which is why he opened Flying Burrito at the baseball park in Durham. When we went to Phil's funeral, it was like a huge family reunion with all the people that had worked there. The writer Sarah Dessen worked there for years. So many people did. The jazz singer Katherine Whalen also worked there, and her mother did too. The Burrito always had this great sense of camaraderie.

—Lee Smith

In addition to creations such as the Ultimate Raging Bull and Flying Mayan burritos, the big personality of Phil Campbell helped make the Flying Burrito a favorite for over two decades.

In 1986, Phil and Vicki Campbell took advantage of the growing popularity of southwestern cuisine and opened the Flying Burrito in a corner space of the strip mall at the intersection of Hillsborough Street and Airport Road. It soon gained an almost cult-like following for its convivial atmosphere and spicy dishes.

Despite the popularity of the Chapel Hill restaurant, many customers actually got their first taste of the Flying Burrito menu in Durham; for years, Campbell sold his burritos at Durham Bulls games. In addition, a small takeout branch of the Flying Burrito was open in Carrboro for a period, and Campbell opened the seafood-focused Flying Fish in Hillsborough. In October 2007, Campbell sold the Flying Burrito to Jim Duignan, who also owned Ba Da Wings in Carrboro. It closed quietly in 2011, and Duignan relocated the Flying Burrito to Raleigh. The original space was taken over by Lucha Tigre, a restaurant that serves a fusion of Latin and Asian cuisine.

FOUR CORNERS

175 East Franklin Street

Few places feel more "UNC" than Four Corners. In August 1979, in a building that had been Rendezvous restaurant and, even earlier, the final incarnation of Harry's, Four Corners was opened by an ownership group of nine people. That group, which included Art Chansky, sports editor of the *Durham Morning Herald*, and Eddie Fogler, a former UNC basketball star who became an assistant coach, named its new restaurant

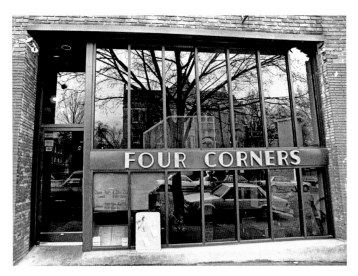

The exterior of Four Corners in 1989. *Photo by Shea Tisdale. Courtesy Durham Herald Collection, University of North Carolina–Chapel Hill.*

Students celebrate a UNC victory in Four Corners during the 1981 NCAA Basketball Tournament. *Photo by Jim Sparks. Courtesy Durham Herald Collection, University of North Carolina–Chapel Hill.*

after Dean Smith's famed offense. Four Corners' original menu also had a sports theme, with sandwiches named after UNC stars, such as the Kupchak super sub, Big McAdoo burger and Fabulous Phil sandwich. It also featured a large bar and was actually was the second restaurant in Chapel Hill with a mixed-drink license. Tar Heel memorabilia covered the walls, and it was soon the hangout for members of many university sports teams

The restaurant was sold in 1984 to former UNC basketball player Hughie Donohue, who operated it for five years. Ownership has changed at least twice more, but Four Corners remains a big part of the Chapel Hill dining and bar scene—even if many current patrons are probably unaware of the heritage of its name.

HAM'S

310 West Franklin Street

Ham's was a great place to watch a basketball game, and I always loved their chips, which came with ranch dressing. It was also the place I went on my twenty-first birthday to celebrate with my first legal beer. A whole yard of beer, actually, in one of those tall, thin glasses that could only be found at Ham's.

—*Sue Holaday*

In 1984, a young banker named Charles Erwin purchased the nearly fifty-year-old restaurant Ham's in Greensboro. He soon began expansion plans and opened a second location in High Point. In the summer of 1986, the third Ham's opened in Chapel Hill in a building that had recently been a florist shop. (There would eventually be twenty Ham's locations.)

The restaurant was constructed on the casual American bar and grill model. It featured menu items such as burgers, sandwiches and beer (Ham's advertised that it offered thirty-one different beers when it opened) and had prices that were attractive to students. The decor included a model train that circled the restaurant on a track near the ceiling, and there was always a game on the TV. Crowds were huge for UNC games.

While the Chapel Hill Ham's remained popular, the chain began to struggle and was sold at bankruptcy in 2010. The Franklin Street location finally closed in 2012 and was replaced by a Mellow Mushroom franchise.

HARRY'S

Several locations on Franklin Street

Long before famed late-night establishments such as Hector's or Time-Out opened, the place to go after an evening on the town was Harry's. For over forty-five years, and in four locations, it was a student favorite for both food and beverage.

In 1926, Harry Stern opened his eponymous grill (actually called Carolina Grill for its first couple of years, then Harry's Carolina Grill and finally just Harry's by the early 1930s) at 126 East Franklin Street. By the mid-

For decades, Harry's was a popular destination for students looking to enjoy a cold beer. Here, owner Ben Schrieber serves one, circa 1950. *Courtesy North Carolina Collection Photographic Archives, University of North Carolina at Chapel Hill.*

1930s, he had moved a few doors down to 118 East Franklin. The eatery had opened in the midst of Prohibition, but when alcohol sales resumed in 1935, Harry's eagerly joined in. A *Daily Tar Heel* article in 1936 stated, "Harry's, which stands for ales, and wines and sandwiches and late hours." It added, "Harry's is open until two at night, except on dance nights, when he closes later in the morning."

Around 1940, Stern sold the business to one of his employees who fortuitously shared the same first name: Harry Macklin. Macklin and his wife, Sybil, ran the grill for four years before selling it to Ben and Syd Schreiber. Though not named Harry, the couple retained the establishment's name. In 1952, the Schreibers decided to get out of the restaurant business and convert their space into a children's clothing store, so they sold the Harry's name. The buyers turned out to be none other than the Macklins, and they reopened Harry's at 171 East Franklin Street.

When a short-lived restaurant called Chuck Wagon called it quits two doors down, the Macklins moved to the much larger space at 175 in 1960. It was there that Harry's, by then officially referred to as a delicatessen rather than a grill, perhaps found its greatest fame. The Macklins were avid supporters of the civil rights movement, so their restaurant was one of the first to desegregate. Because of this, it was often the meeting place for those who were about to stage protests at other establishments.

The end of the Harry's story in Chapel Hill came in early 1972. When the lease expired, the owners decided to close the doors (and bar) for good.

HECTOR'S

201 East Franklin Street

Hector's was only a late-night spot for so many students in Chapel Hill. And, true, I was also introduced to it late one night out doing something I probably shouldn't have been doing. I remember standing in a VERY raucous line—second only to Time-Out)—staring up a menu, which was somewhat obscured by the burger steam rising from below it.

Not sure, but I seem to remember the Greek Grilled Cheese as being my go-to that first night, probably due to it being priced right. The nervousness of making sure I could bark my order out as quickly and correctly as possible to the guys behind the counter seemed to be harder than most oral

exams I had at UNC and reminded me of not only Billy's Time-Out banter but SNL's Cheezborger Cheezborger skit. It surely felt a rite of passage during my college years.

By my junior year, I would upgrade my Greek Grilled Cheese to include a couple of burger patties—because why just one?—and that became my mainstay for the next couple of years as I transitioned from Hector's being my late-night spot to it being my go-to lunch spot, since I practically lived one hundred feet from its corner door.

—Josh Wittman

Of all the restaurants that have existed in Chapel Hill, perhaps the only one that could challenge the Rathskeller as the most memorable to the student population was Hector's. Located directly across the street from the campus, it served up original creations such as the Greek grilled cheese and the cheeseburger on pita for more than thirty years. Its T-shirts, bearing the slogan "Famous Since 1969" and with a list of 20 Hector's Rules on the back (including "everything is better on a pita" and "this is not a fat-free restaurant") were nearly as popular as the food.

In 1969, Pete Galifianakis, owner of a bar called the Tempo Room (and brother of U.S. representative Nick Galifianakis), opened Hector's on the corner of Franklin and Henderson Streets. In its first years, the restaurant featured a menu that focused on hot dogs, burgers and fish and chips. Its popularity led Galifianakis to take the Hector's concept beyond Chapel Hill, and he even had a location in Raleigh's Crabtree Valley Mall for a period.

A fire in March 1975, resulted in a temporary closing of the establishment. Soon afterward, the ownership of Hector's changed, when brothers Steve, Mike and Nomikos Lias bought both Hector's and the Continental Café next door. They owned them until 1989. At Hector's, the Lias brothers changed the menu to combine traditional Greek flavors, such as tzatziki sauce, with American favorites like burger patties and tater tots. Students soon discovered that Hector's offerings, though popular at lunch, made for the ideal post-barhopping snack. The line to place an order at the counter often stretched out the door on a weekend night.

In early 1991, another fire—this time at the adjoining Continental Café—brought an end to Hector's in its original location. The damage resulted in its closing while renovations to the building took place. At the same time, a legal dispute arose between the business owner and the landlord. The building remained vacant until 1994, when the original

space was leased to Caffe Trio, an upscale dessert and coffee house. The following year, however, Hector's made a comeback and reopened upstairs from its original location. In 2006, the famed eatery was forced to move again when the landlord decided to use the space for a dance club (East End Martini Bar). It reopened in a smaller space at 108 Henderson Street in March 2006. That incarnation of Hector's quietly closed in late 2007, but it was not the end of the story.

A few years later, the name Hector's was resurrected. In 2011, the Thrill, a bar at 157 East Rosemary Street (the old Jordan's Steakhouse location) began offering much of the original Hector's menu from what it called the Thrill at Hector's. The venture (and the bar) proved to be short-lived, however. Ironically, in 2014, Hector's original space was taken over by Time-Out, its longtime rival for the town's late-night dining business.

IL PALIO

1505 East Franklin Street

The Siena Hotel and its acclaimed Il Palio restaurant have been offering a bit of Italy in Chapel Hill for over thirty years. Named for the Tuscan town that inspired it design, the Siena opened in 1987 at the former site of Brady's restaurant. Its own restaurant, bearing the name of the famous horse race that takes place in the town of Siena, is now one of North Carolina's top destinations for fine dining.

According to its own description, Il Palio "marries the traditional flavors of Italy with a casual elegance that showcases the culinary roots of rustic Italian cooking." That approach has earned it a four-diamond rating from AAA, one of only seven restaurants in the Triangle region to do so. Il Palio has had the rating the longest of these (since 1990) and is the only one that focuses on Italian cuisine. Its other honors include *Wine Spectator*'s Award of Excellence. The chefs, including Adam Rose and Teddy Diggs, who have run the restaurant, are some of the most well known in the region, and several have gone on to open their own restaurants

ITALIAN PIZZERIA III

508 West Franklin Street

IP3, as it is called, is a Chapel Hill tradition that has been serving up authentic Italian pizza for over forty years. In the late 1970s, the first two Italian Pizzerias opened in Durham, followed by the Chapel Hill location in 1980. In 1996, brothers Angelo and Vincenzo Marrone came from Naples to take over the Chapel Hill establishment from their uncle, the original owner. The big personalities of the Marrone brothers and their love of international soccer and Tar Heel basketball, both of which are frequently shown on the television, have made IP3 one of Chapel Hill's most beloved destinations for pizza and other Italian specialties.

K&W CAFETERIA

201 South Estes Drive

It almost seems odd to include a cafeteria—today often associate with budget-conscious retirees—in the same list as some of Chapel Hill's fine-dining establishments, but K&W Cafeteria has played an important role in the town's restaurant culture for well over forty years.

Resurrecting the tradition of the student cafeterias that were popular in Chapel Hill in the 1930s, K&W Cafeteria was an original tenant when University Mall opened in the summer of 1973. It was part of a chain that began in the 1930s in Winston-Salem and is still run by the founding family today. Though cafeteria-style dining eventually went out of vogue in many places by the 1990s, K&W prospered. As of this writing, the chain has over twenty-five locations, most in North Carolina, with a few in neighboring states.

LA RÉSIDENCE

220 West Rosemary Street/202 West Rosemary Street

In the mid-1970s, no one would have thought that Chapel Hill would soon become a destination for French country cuisine, but it did. A pair of young chefs, Bill Neal, who had been cooking at Villa Teo in Chapel Hill, and his wife, Moreton, who had been at Durham's Hope Valley Country Club, decided to open their own establishment. In 1976, they launched their restaurant at Fearrington Village in Chatham County, a redevelopment of an old farm a few miles south of Chapel Hill.

In 1977, the Neals decided to relocate to town and moved their restaurant to an old house on Rosemary Street. There it soon earned acclaim for its creative dishes and elegant atmosphere. After a divorce, Bill Neal left in 1982 to cofound Crook's Corner, but Moreton Neal continued to run La Res. Under her guidance, it became one of the state's top dining destinations and was even named to a list of the one hundred best restaurants in the nation by *Gourmet* magazine.

Moreton Neal, cofounder of La Résidence in the late 1980s. *Courtesy Durham Herald Collection, Digital NC.*

Neal and chef Bill Smith ran the restaurant until 1992, when it was sold to the Gualtieri family. In the years since, Le Résidence has gone through another move (just down the street) and survived a major fire, but Frances Gualtieri and her sons have helped the restaurant maintain its legendary status in the culinary world.

LANTERN

423 West Franklin Street

The first real fancy meal I ever treated myself to was at Lantern, seated in a both at the lush red bar. I was eighteen and hanging out with my British suitemate, who I thought was super glam and mature at age twenty. We split a bento box, and all I remember is sharp tangy pickles and fresh seafood. And, you know, just feeling like a real grownup. By the time I turned twenty-one, I'd be back at the bar almost once a week drinking Pimm's cups. Lantern's menu has always been ahead of its time, inspired by hyper-local, seasonal ingredients. Lantern felt incredibly exciting to me when it first opened, playing with sour and spicy flavors new to my teenage palate. It's where I first bit into a green coriander seed or began to understand the depth of fish sauce. I still go there to celebrate something special, and the menu continues to surprise me.

—Victoria Bouloubasis

Once upon a time, it would have been extremely surprising to find one of the country's most progressive Asian restaurants in Chapel Hill, but that is exactly what Lantern is. In early 2002, the sibling team of Andrea and Brendan Reusing opened a restaurant that describes its menu as "a marriage of Asian flavors and North Carolina ingredients sourced mainly from local farms and fisheries." Lantern's unique interpretation of dishes soon drew national attention. It was named among America's Top 50 Restaurants by *Gourmet* and one of America's 50 Most Amazing Wine Experiences by *Food & Wine*. In addition, Lantern was named Restaurant of the Year in 2009 by Raleigh's *News & Observer*.

Andrea Reusing herself also has won great fame. She was featured in *Gourmet* magazine in 2008, and in 2011, she was awarded the James Beard Foundation award for Best Chef Southeast. Her first book, *Cooking in the*

Moment: A Year of Seasonal Recipes, was named one of 2011's most notable cookbooks by the *New York Times*. Reusing has since taken on the additional duties of serving as the executive chef of the Durham Hotel, but Lantern continues to be on of Chapel Hill's most acclaimed restaurants.

LINDA'S

203 East Franklin Street

It was amazing the people you would meet working at a place like Linda's. You get to know customers; we had lots of them that worked at university, and it was sort of a hangout for medical students as well as the Daily Tar Heel *staff. The employees of one company all came in every Friday payday. We had nicknames for some regular customers and would even call to check on them if they didn't show up. One young guy who came in a lot had all of his belongings in his car. We thought he was homeless, but after talking to him, it turned out he was actually a Duke doctor. He's still a cardiologist today. It was a great environment because the employees and customers became sort of a family.*

—*Kim Scott*

The primary key to long-term success in the restaurant industry is finding a niche in the community. That is exactly what Linda's has done. Nothing fancy, the bar and grill has been offering good food and an inviting atmosphere for forty years.

In 1975, former NASCAR driver Raymond Williams, who also owned Ye Old Tavern down the hill on East Franklin Street, and his wife, Linda, opened a bar and grill called RW's on North Columbia Street. The space, directly behind what would soon become Spanky's, had recently been the Scoreboard bar and grill and, before that, Tar Heel Sandwich Shop. The Williamses renovated the space and decorated with old church pews and salvaged stained-glass windows.

After a divorce, Linda Williams took over the business and changed its name to her own. In the mid-1980s, the lease on the building ran out, and Linda Williams decided to close. In 1988, however, she reopened Linda's in a basement-level space under Sadlack's Subs at 203 East Franklin. When Sadlack's closed in 1991, Linda's expanded to take over two levels of the

Linda Williams behind the bar at the first location of her establishment. *Courtesy Kim Scott.*

building; the main bar and grill occupied the ground floor while the basement became known as the Downbar. In 2003, Williams decided to retire and sold the business to Rutland Tyler. He sold it to Chris Carini in 2011. Despite the ownership changes, the name has remained, and Linda's continues to be a popular destination for burgers, beer, cheese fries and more.

MAMA DIP'S KITCHEN

405 West Rosemary Street/408 West Rosemary Street

Mildred "Mama Dip" Council, one of Chapel Hill's most-celebrated culinary figures, began her cooking career in the kitchens of UNC fraternity houses. She later worked for her mother-in-law at Bill's Barbecue, a small takeout restaurant on Graham Street, before being encouraged to open her own eatery. In 1976, Dip's Country Kitchen was born in a small space on West Rosemary Street. It featured traditional southern cooking and offered only eighteen seats to customers. Demand quickly grew in those

Joe Council at work in the kitchen of Mama Dip's in 1984. *Photo by Charles Cooper. Courtesy Durham Herald Collection, University of North Carolina–Chapel Hill.*

early years—much of it takeout due to the limited seating—so in 1985, Council expanded the restaurant to ninety seats by taking over the vacant location next door. That same year, her fame grew beyond Chapel Hill when *New York Times* food critic Craig Claiborne praised the restaurant in his column.

In 1999, ever-increasing popularity led Council to expand again. She bought an empty lot across the street and built an entirely new Mama Dip's Kitchen from the ground up. Her first cookbook, *Mama Dip's Kitchen*, was published by UNC Press in 1999. It proved enormously popular and led to a sequel, *Mama Dip's Family Cookbook*, in 2005. Today, these books can be found on the kitchen shelves of thousands of cooks across the country. Mama Dip's reputation even brought the restaurant national television attention, and it was featured on the Food Network's *$40 a Day with Rachael Ray*.

Mama Dip's has always been a family business, and even after Mildred Council's death in 2018, several generations of the Council family continue to run it. A few have even gone on to open their own related businesses; daughter Julia opened her own restaurant, daughter Annette started a cake mix company and granddaughter Tonya launched a cookie company (in the original location of her grandmother's restaurant).

MARGARET'S CANTINA

1129 Weaver Dairy Road

In 1989, Margaret Lundy became the chef and part-owner of a small take-out joint called Chick-It-Out in Timberlyne Shopping Center. Three years later, that business morphed into Margaret's Cantina. Lundy had grown up in Arizona, and her new restaurant fused the flavors of the Southwest with local and seasonal North Carolina harvests. The restaurant soon became a neighborhood favorite and a happy discovery for those who ventured to north Chapel Hill. That popularity allowed Lundy to move her business to a larger space when one opened across the shopping center. Margaret Lundy retired and sold her restaurant in 2014, but the new owner retained the name and menu.

MARIAKAKIS

1322 Fordham Boulevard (U.S.15-501)

For nearly sixty years, Efthimios "Tommy" Mariakakis was one of the most recognizable restaurateurs in Chapel Hill. In 1938, he partnered with his uncle to run Marathon Sandwich Shop at 115 East Franklin Street. It was in business for fourteen years, during which time Mariakakis also had a café in Carrboro. He followed that with other ventures, including a linen service, and in 1963, opened Kwikee Take-Out and Keg Room in three-year-old Eastgate Shopping Center. Located next door to a barbecue joint called Pig & Puppy, Mariakakis's eatery specialized in pizza and beer.

Over the years, the restaurant began to expand its menu and add more traditional Greek and Mediterranean specialties (such as roasted lamb shank). By the early 1970s, advertisements began to refer to the establishment as Kwikee Take-Out and Mariakakis Bakery. A decade later, it was referred to only as Mariakakis Restaurant.

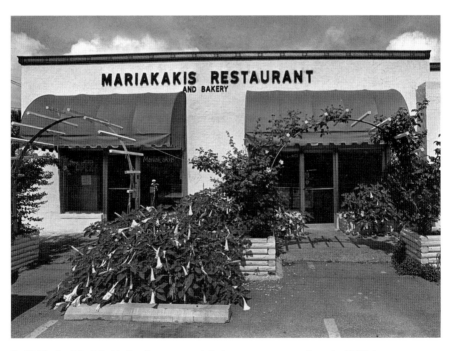

In 1997, the Mariakakis family converted their restaurant, seen here in 1989, into a specialty food store. *Photo by Dan Charlson. Courtesy Durham Herald Collection, University of North Carolina–Chapel Hill.*

In addition to its large restaurant space (expanded over the years), it offered a deli, bakery and gourmet grocery items. When Tommy Mariakakis died in 1997, his son, Johnny, continued to run the business but soon decided to transform it from a restaurant to specialty food store named Mariakakis Fine Wine and Food. Though the restaurant portion of the business may be gone, the name Mariakakis still elicits fond memories from generations of UNC students.

MEDITERRANEAN DELI

410 West Franklin Street

Jamil Kadoura began his food industry career as a teenager, working at a falafel stand in his native Palestine. He immigrated to the United States for education and eventually became the food and beverage director for a hotel. In 1992, with the help of his family, he decided to open his own establishment. Kadoura found a small space on West Franklin Street, and in it, Mediterranean Deli was born. It its early years, it had seating for just twelve customers and offered only five items in its six-foot deli case.

In the years since, the business has expanded immensely and become a student favorite. The huge deli case now features over sixty different items from all over the Mediterranean region, as well as a bakery that makes its own pita bread and a market. In 2018, Kadoura opened a second Mediterranean Deli location near Elon University.

MERRITT'S GRILL

1009 South Columbia Street

Originally opened in 1929 by Eben and Ruby Merritt as an Esso station, Merritt's is one of the oldest businesses in Chapel Hill. Its fame as a restaurant, however, came many years later. In 1991, Robin and Bob Britt bought the gas station/convenience store and continued to operate it as it had been for years. It did have a small grill in the back that served food, but it was not the primary focus of the business.

In 2008, that changed. With the business struggling and the gas pumps gone, the Britts decided on a different approach. The interior of the building was remodeled to reflect a new emphasis on food, particularly southern staples. Burgers, chicken salad and pimento cheese were added to the menu, but it was one item that has brought Merritt's fame: the bacon lettuce tomato sandwich, commonly known as the BLT. Today, during summer tomato season, customers are often lined up out the door to get one of the hundreds of BLTs that Merritt's will sell on a busy Saturday. The sandwich has become so famous that it has been written up in *Our State*, *National Geographic Traveler* and *Every Day with Rachael Ray*. The *Raleigh News & Observer* named it to a list of the twenty-five tastes that define North Carolina, and in 2019, *People Magazine* named the BLT with pimento cheese the best sandwich in North Carolina.

PEPPER'S

127 East Franklin Street/144 East Franklin Street/107 East Franklin Street

For twenty-five years, if you were a student craving a late-night slice of pizza, there was only one place to go. Pepper's Pizza was founded in the summer of 1987 by David "Pepper" Harvey and Erwin Shatzen. Harvey was the owner of Chapel Hill's popular Schoolkids Records at 127 East Franklin Street. When a larger space became available across the street, he moved his record store there. Not wanting to give up the original space, Harvey decided to enter the pizza business and opened Pepper's in the former Schoolkids space.

The new restaurant was unlike any previous pizzeria in town. When Pepper's opened, it had no waitstaff and only thirty seats. Customers ordered at the counter near the ovens and waited for their names to be called when their pizza was ready. There were no red-checked tablecloths, no traditional Italian theme and the list of ingredients included items unheard of with regards to pizza, such as zucchini, spinach, sundried tomatoes and artichoke hearts. It even offered pizza by the slice, which many other establishments did not do. The business proved so successful that in 1989, Pepper's expanded into the space next door, which increased seating to eighty-five customers.

In addition to its colorful employees know for unique hairstyles and clothing, the décor of Pepper's was always part of its charm. In the early years, graffiti by customers covered the walls (later replaced by a psychedelic mural), and a mannequin torso was stationed at the door with "Please wait

to be seated" painted across its chest. When the restaurant moved up the block to 107 East Franklin Street in 2006, a collection of nineteen paintings featuring famous North Carolina musicians filled the walls. The paintings, by muralist and UNC grad Scott Nurkin, depicted artists ranging from John Coltrane to Randy Travis. Fortunately, when Pepper's closed for good in 2013, the paintings were purchased by UNC's Department of Music and now reside in Hill Hall.

THE PINES

Raleigh Road (Corner of Highway 54 and Finley Golf Course Road)

For years, the Pines was probably the Chapel Hill restaurant where one was most likely to run into past and present athletes and coaches. Owned by Leroy and Agnes Merritt for years, the town's upscale steakhouse was the site of pregame meals for the basketball team and a destination for returning alumni.

Open by 1941, the Pines was the place to go for UNC professors and staff looking to enjoy a nice dinner out. Since it was often beyond their financial means, many students reserved it for celebrating a special occasion (particularly graduation). The Pines always maintained a close connection with the UNC community; in the 1940s, it even ran a contest in the *Daily Tar Heel* offering a free T-bone steak dinner to the student who correctly guessed the number of rushing yards the football team would gain in a game.

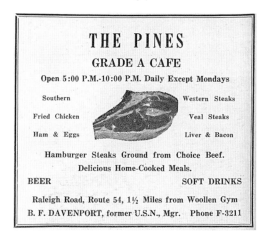

This 1947 advertisement for the Pines appeared in the university's guidebook for new students. *The Carolina Handbook 1947–1948, University of North Carolina–Chapel Hill.*

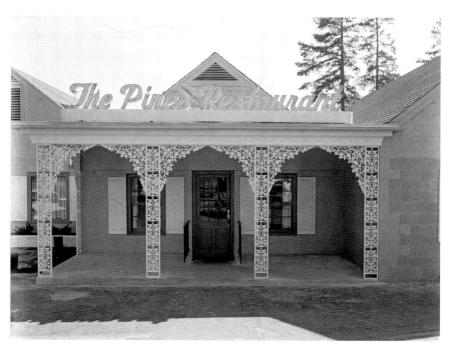

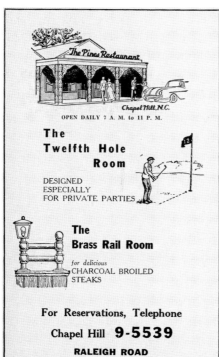

Above: The entrance to the Pines, circa 1960. *Courtesy North Carolina County Photographic Collection, University of North Carolina–Chapel Hill.*

Left: A Pines advertisement from *Hill's 1962 Chapel Hill City Guide. Courtesy Digital NC.*

The Pines was nearly destroyed by a fire in late 1974. Shortly thereafter, the Merritts decided to retire and sold the restaurant to James "Slug" Claiborne, a Charlotte restaurateur who had graduated from UNC. He reopened with a new name, Slug's at the Pines, and the restaurant remained one of Chapel Hill's more prestigious (and expensive) dining spots until the mid 1990s. The restaurant was sold again, in 1995, to UNC alums Ken and George Davis. They renovated the building, updated the menu and changed the name back to the Pines. The venture proved unsuccessful, however, and the building was sold. In 1998, the landmark building became home to Aurora restaurant, which had been located in Carr Mill Mall. When it closed in 2007, the site was redeveloped.

THE PORTHOLE

100 Porthole Alley

I loved the rolls, fried chicken and sweet tea at the Porthole on Sundays when I was at the university. The distinguished servers, wearing starched white shirts and bow ties, would bring a pitcher full of tea so I could refill my glass as needed. The Porthole also had a few booths with just one bench, which was ideal for someone eating alone. It was a very sad day in the late 1980s, when I revisited the campus to find that the Porthole was closed forever.

—Graham Flynt

In the alley called Old Fraternity Row, just off Franklin Street near the Carolina Coffee Shop, the Porthole restaurant was opened in 1942 by former UNC students Morris Timmons and Willard Marley. The building was originally a garage and then a beer joint that was the site of frequent brawls.

The new establishment was decidedly more upscale, according to a *Daily Tar Heel* report before it opened. The description stated that it was "interspersed with realistic port-holes, sea murals covered the walls. A curved chromium-trimmed bar is at the far end of the room. The seats of the booths are covered with red leather and trimmed with chromium." Despite seeming fancy, the Porthole gained a reputation as an inexpensive restaurant that was known for its homemade rolls, salads and homestyle dinners. Customers at the Porthole also filled out their own orders, which distinguished it from other local restaurants.

Members of the staff inside the Porthole in 1964. *Courtesy Roland Giduz Photographic Collection, University of North Carolina–Chapel Hill.*

In 1981, the owners converted a former storage space above the Porthole into a bar called the Upper Deck. Four years later, however, both businesses closed, citing financial troubles. The building was sold to UNC and has served as offices since.

PYEWACKET

452 West Franklin Street/431 West Franklin Street

One of the early leaders of the natural foods movement in the area was Mary Bacon. She had opened the very popular SomeThyme restaurant in Durham in the early 1970s. A few years later, she decided to buy a small natural foods restaurant in Chapel Hill called Wildflower Kitchen with her husband, David. After renovations, the restaurant reopened in 1977 as Pyewacket.

In 1980, Pyewacket moved across the street to a much larger space in the old Long Meadow Dairy building, around which the new Courtyard

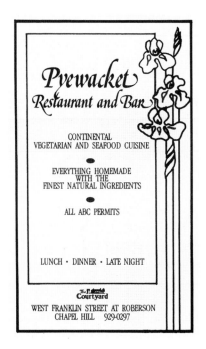

Left: For twenty-five years, 1977–2002, Pyewacket was a Chapel Hill institution thanks to its menu of unique vegetarian and natural foods dishes. *Collection of the author, 1983 advertisement.*

Right: The entrance to Pyewacket in 1991. *Photo by Chuck Liddy. Courtesy Durham Herald Collection, University of North Carolina–Chapel Hill.*

development was being built. The restaurant soon became a Chapel Hill favorite for its unique, mostly vegetarian menu and jazz nights. Pyewacket closed in 2002, and the space was taken over by a Malaysian/Thai restaurant called Penang. This was followed by Kipos Greek Taverna in 2013.

RAM'S HEAD RATHSKELLER

157 East Franklin Street

My favorite place to eat in town was the Rathskeller. I loved the lasagna, salad dressing, garlic bread and sweet tea, and I always ordered the same thing. I did have the spaghetti a couple of times but only because it was on special and super cheap in the 1980s. It may have been dark and dingy, but

it was an institution, and those who never experienced it missed something special. It was truly a sad day when that place closed.

—*Alison Brewbaker*

At the Rathskeller, they had that one booth that was directly underneath the Franklin Street sidewalk. There were those glass pieces in the ceiling where you could see the sunlight coming down. I never actually got to sit in that booth, but it existed. And I remember the lasagna there—so much cheese!

—*Todd Hierman*

Talk to people all over the world, and when Chapel Hill comes up, the Rathskeller is always mentioned. It was very memorable, and I've never seen anything else like it. I think it worked because of my father's business sense and my mother's creativity and sense of design.

—*Avery Danziger*

In 1974, the *Franklin Street Gourmet*, a student-produced guide to dining in town, wrote, "The 'Rat' is a peculiar institution in Chapel Hill. We're not exactly sure where its charm or perversion comes from, but sooner or later, nearly everyone in town indulges in it....It might simply be the fact that this type of place is simply a phase through which every generation of collegians passes, later to recall the time they sat with one of their first college dates and carved their names on the booth, or the time friends each guzzled a pitcher of beer in less than a minute." The publication gave a less-than-glowing review of the food, but it acknowledged the most important fact about the restaurant: the memories made there were among many students' most unforgettable.

In 1947, Ted Danziger, the son of Edward "Papa D" Danziger, began digging out the basement beneath his father's Vienna Candy Kitchen. The following year, he turned the cave-like space—complete with fake stalactites in one room—into a restaurant. The Ram's Head Rathskeller, frequently called just the Rat, featured numerous rooms, each with names relating to their own unique décor. They included the Circus Room, the Train Room, the Spanish Room and the Chicken Coop, from which fried chicken had been sold to students in the alley in the early days of the restaurant.

In addition to the menu and the décor, the staff of the Rat, who each had a nickname, was extremely memorable. Many worked in the restaurant for years and even served multiple generations of diners. For example, John

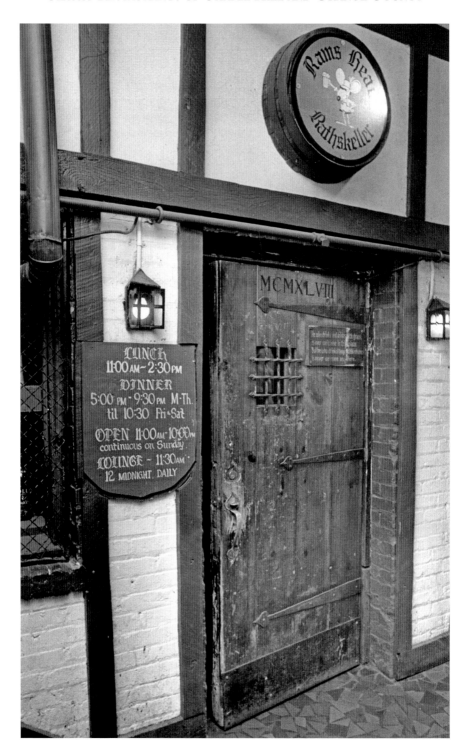

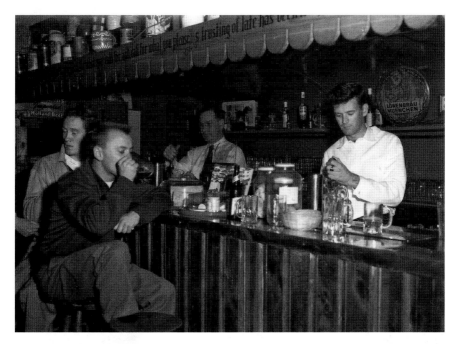

Opposite: The entrance to the Ramshead Rathskeller in 1989, little changed from when it opened forty years earlier. *Photo by Chuck Liddy. Courtesy Durham Herald Collection, Digital NC.*

Above: The Rathskeller's bar, seen here in the 1950s, was long a popular beer-drinking destination for students. *Courtesy Chapel Hill Historical Society Collection, Digital NC.*

"Squeaky" Morgan waited tables from 1960 to 1993 and then again from 2002 to 2007. Framed caricatures of the staff lined the walls.

The food was also popular for its creativity, if nothing else. In addition to pizza, there was the Gambler (or Double Gambler if one was extra hungry), which was served in a sizzling cast-iron pan, or the lasagna that was served in a bowl with long strands of cheese that made it a challenge to eat. And then there was the Hot Apple Pie Louise for dessert.

The Danziger family sold the restaurant in the 1990s. It continued on until 2008, when it closed due to tax problems. There were numerous attempts to resurrect it, but none were successful. In 2019, the space became a taproom for Raleigh-based Gizmo Brew Works. Today, for numerous reasons, the Rathskeller remains one of Chapel Hill's most storied restaurants. It served countless student in multiple generations and remains a subject of alumni discussions.

RANCH HOUSE

Airport Road

One of the amazing things about the Ranch House was that everyone in the world showed up there. All kinds of celebrities who were visiting or had business at the university. I remember Senators Jesse Helm and Sam Ervin, Neil Armstrong (astronauts trained at the planetarium) and the Supremes. For a small child, that was all very exciting. I even remember being introduced to Liberace.

—Avery Danziger

After his Rathskeller venture proved successful, Ted Danziger opened the Ranch House in 1953. Featuring an open hearth and a Western theme, the restaurant—like other Danziger creations—was unique. In his mid-1950s review, Duncan Hines wrote, "A real ranch house—long and low—with a stove pipe chimney. One of the novelties is the Saddle Bar. Spec: Charcoal

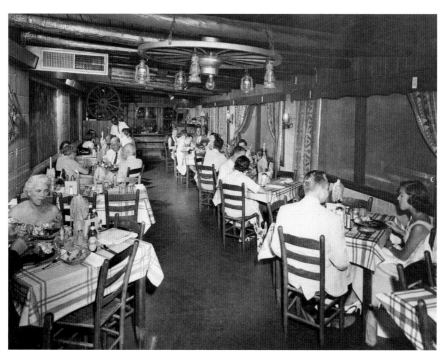

Diners at the Ranch House, circa 1960. *Courtesy Durham Herald Collection, University of North Carolina–Chapel Hill.*

A somewhat kitschy 1965 menu from the Ranch House. *Collection of the author.*

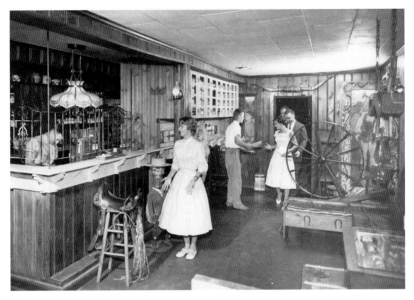

Inside the entrance to the Ranch House. *Courtesy Durham Herald Collection, University of North Carolina–Chapel Hill.*

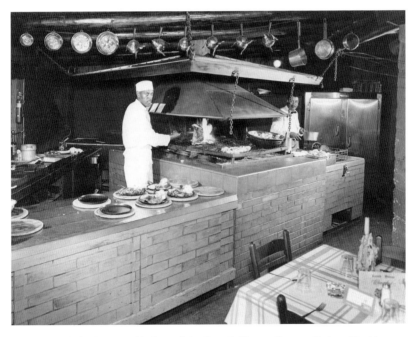

Grilling steaks in the open kitchen of the Ranch House. *Courtesy Durham Herald Collection, University of North Carolina–Chapel Hill.*

broiled hickory smoked Omaha steaks, flaming Shish-kebob." He added that dinners cost from two to five dollars, and reservations were required on football weekends. For over twenty-five years, countless Chapel Hillians and visitors enjoyed a Ranch House steak dinner; its Sunday buffet was also a popular attraction

The Ranch House closed at the end of the 1970s to be replaced by Fosdick's Seafood. In 1981, the location became Crazy Zack's nightclub before being replaced by an office building in 1983.

SPANKY'S

101 East Franklin Street

In 1975, Harrison "Mickey" Ewell launched his first Chapel Hill restaurant venture: Harrison's, a Georgetown-themed restaurant, downstairs at 149 East Franklin Street. Two years later, Chapel Hill's most prime piece of real estate became available: a building that was home to Sloan's Drugstore before being converted into a franchise of the Mayberry Ice Cream and Sandwich Shop chain. Ewell decided it was the perfect opportunity to open a second establishment, and Spanky's, a restaurant that would become one of the town's most iconic, was born in September 1977. Modeled after restaurants in the Georgetown area of Washington, D.C., its décor featured

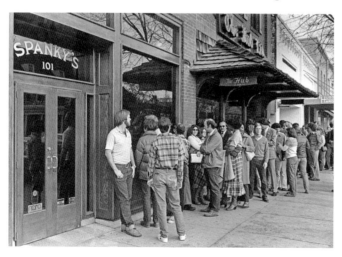

Customers wait for the opening of Spanky's. *Photo by Harold Moore. Courtesy Durham Herald Collection, University of North Carolina–Chapel Hill.*

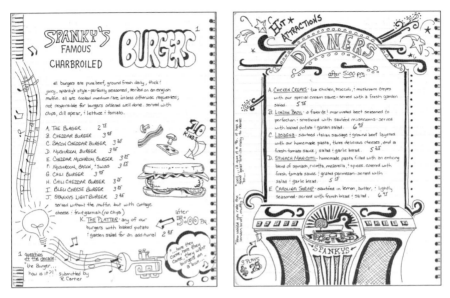

Pages from Spanky's menu in 1981. *Courtesy Greg Overbeck/Chapel Hill Restaurant Group.*

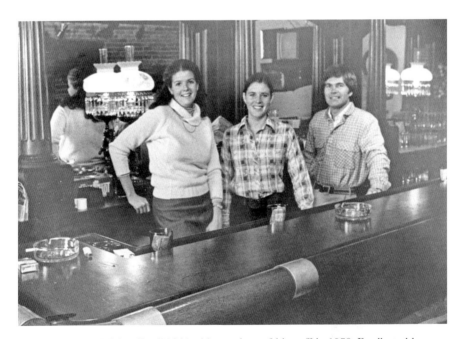

Spanky's founder Mickey Ewell (*right*) with members of his staff in 1978. Ewell would go on to be named the 2009 Restaurateur of the Year by the North Carolina Restaurant and Lodging Association. *Photo by Charles Cooper. Courtesy Durham Herald Collection, University of North Carolina–Chapel Hill.*

exposed bricks, varnished wood and brass trim—a vast departure from the pink walls of Mayberry's. Spanky's menu was also ambitious and diverse but had prices that would not deter students.

Spanky's eventually became the flagship restaurant for the Chapel Hill Restaurant Group, which included Ewell and later partners Greg Overbeck, Kenny Carlson and Pete Dorrance. It remained consistently popular for lunch, dinner, drinks and weekend brunches for generations of UNC students. After forty years, however, the ownership group decided Spanky's had run its course and transformed the restaurant into a new establishment, Lula's.

SQUID'S

1201 Fordham Boulevard (U.S.15-501)

The South has long been known for its fried seafood, but in 1986, Squid's brought new and creative concepts in preparing fresh fish to Chapel Hill. Mickey Ewell, owner of Spanky's, partnered with longtime employees Greg Overbeck, Kenny Carlson and Pete Dorrance to form Chapel Hill Restaurant Group. They took over a building that had been home to Sonny's Barbecue and created a new establishment that included a thirty-seat oyster bar, a one-hundred-seat restaurant area and a fresh seafood market.

For over thirty years, Squid's has remained true to its mission of offering the freshest seafood and is a consistent leader in the Chapel Hill

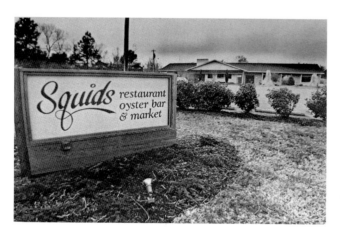

Squid's has been named the Best Seafood Restaurant in the Triangle by *Indy Week* and Best Seafood Restaurant in Chapel Hill by *Chapel Hill Magazine*, both multiple times. *Photo by Mark Chuck Liddy. Courtesy Durham Herald Collection, University of North Carolina–Chapel Hill.*

restaurant industry. Among its honors is being chosen as the 2004 Rose Award winner for Best Overall Restaurant in Chapel Hill by the readers of the *Chapel Hill Newspaper*.

SUNRISE BISCUIT KITCHEN

1305 East Franklin Street

One of Chapel Hill's most recognized dining destinations is a drive-thru eatery that is only open from 6:00 a.m. to 2:30 p.m. Using his grandmother's biscuit recipe, David Allen opened Sunrise Biscuit Kitchen in 1984 in a former convenience store. Today, the establishment has a menu that offers numerous options, such as ham, steak and porkchop, as additions to the reported 1,500 biscuits it serves per day. There is even the gigantic and now-famous Bad Grampa biscuit that includes chicken, egg, cheese and bacon.

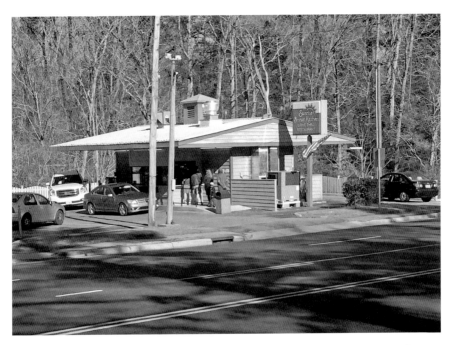

Cars are often backed up into Franklin Street on weekend mornings as customers wait to order at Sunrise Biscuit Kitchen. *Photo by Chris Holaday.*

Sunrise Biscuit Kitchen does have a walk-up window where customers can order, but on many mornings, a line of cars filled with hungry customers waiting to order is backed up on Franklin Street. That line attests to the fame that the eatery, which has another location in Louisburg, has gained. Sunrise Biscuit Kitchen has landed on *Southern Living*'s list of the South's Best Breakfast Spots. Among its many other honors are Best Biscuits in the US by *Food & Wine*, Top 5 Breakfast Destinations in the US by the Food Channel and Best Breakfast in North Carolina by *Food Network Magazine*.

SUTTON'S

159 East Franklin Street

Pharmacists and brothers-in-law James Sutton and J.L. Alderman founded Sutton and Alderman's Drug Store in 1923. Like many drugstores of the day, it featured a lunch counter/soda fountain that offered drinks and sandwiches, but the focus was on the pharmacy and retail. The store offered everything from tobacco to stationery to music records and once included a toy department and a cosmetics counter. Alderman left the business after a few years (he opened his own pharmacy in Wake County), but Sutton and his wife, Lucy, continued to run the business. Sutton died in 1950, and after several years, Lucy sold the business.

Pharmacist and UNC graduate John Woodard bought the store in 1977. In 1984, he removed some of the retail offerings to expand the eating area. Around the same time, a tradition of posting photos of smiling diners on the wall began. Today they (and plenty of Tar Heel memorabilia) cover the walls. Another part of the Sutton's tradition is its longtime employees. The much-loved Willie Mae Houk cooked for customers for over thirty years. Don Pinney learned from her, went on to run the grill for years and then took over as owner when John Woodard retired in 2014. The pharmacy part of the business has closed, but Pinney has continued the tradition of serving breakfast and lunch to countless Chapel Hill residents and visitors.

TIME-OUT

133 West Franklin/201 East Franklin Street

You could find him working the 10:00 p.m. to 4:00 a.m. shift at Time-Out Chicken and Biscuits, subjecting patrons to a barrage of harsh but deserving character assassinations. Customers actually went to Time-Out to be verbally abused by Billy Ray Penny. They waited in long lines for his clever digs, sarcastic put downs and slanderous insults. Because of Billy, Time-Out served up a harmonious balance of grease and attitude. That amazing chicken, egg and cheese biscuit was perfect for absorbing alcohol after a long night on Franklin Street. And yet, much of the allure of Time-Out was Billy's large personality. And, perhaps, what Tar Heel basketball player you might meet in line while waiting for that one-dollar bucket of bones.

—Danny Rosin

A large square biscuit filled with fried chicken and covered in melted cheddar cheese might be the most popular food item in Chapel Hill. Served by the iconic Time-Out restaurant, it is considered a rite of passage for UNC students and a must for visitors. It is so well known that it was even featured in an episode of the Travel Channel's *Man vs. Food*, starring Adam Richman. Time-Out does serve other southern staples, such as pork barbecue, macaroni

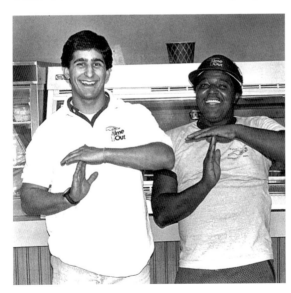

In the 1980s and '90s, Billy Ray Penny (*right*) was a legendary character at Time-Out. Here he gives the "time-out" signal with UNC class president Danny Rosin in 1989. *Courtesy Danny Rosin.*

and cheese and collard greens, but it is the chicken and biscuits that have had people lining up out the door for over forty years.

Eddie Williams, a UNC alumnus, opened Time-Out in 1978. He soon realized that the late-night crowd was lacking in food options, so he changed his restaurant's hours to simply say "Never Closed." Time-Out soon became a favorite and affordable destination for students after a night of bar adventures. In 2014, due to the redevelopment of University Square, Time-Out was forced to relocate. Its doors closed for the first time in more than thirty-five years but soon reopened a couple of blocks to the east in the space that had once been occupied by Hector's.

VILLA TEO

1213 East Franklin Street

The Danziger family was known for its unique restaurants and Villa Teo continued the tradition. In the mid-1960s, they took on a large Italianate villa constructed from remnants of several Durham mansions that had been torn down. It was converted into a restaurant and event space that featured a European menu and was particularly known for its extensive wine cellar and Sunday brunch.

In the early 1970s, Bill Neal, perhaps Chapel Hill's most legendary culinary figure, got his start at Villa Teo as an apprentice cook while attending graduate school at UNC. He was eventually promoted to chef de cuisine. Moreton Neal, his wife, was cooking at Hope Valley Country Club in Durham. She eventually followed her husband to Villa Teo and became the pastry chef. In 1975, Bill Neal was interviewed by the *Daily Tar Heel* and said, "Restaurants are being taken over by frozen food corporations," he said. "There aren't any more cooks, just thawers. Here at the Villa Teo we make everything from scratch." He added, "I wouldn't mind being a cook for the rest of my life. It's challenging. You have to use your mind and it's physically demanding. And you get to see the results." The next year, the Neals ventured out on their own and opened La Résidence.

In later years, Bibi Danziger actually lived in the building, above the restaurant. It closed in the mid-1980s and was transformed into a well-known antique store, Whitehall at the Villa.

YE OLDE WAFFLE SHOPPE

173 East Franklin Street

When I was growing up, the family would sometimes go to Ye Olde Waffle Shoppe on Sundays after church. That was good, and it hasn't changed much. Go in there today, and the décor, the booths and counter are pretty much the same. It's just this little hole in the wall but it has great breakfast food.

—*Todd Hierman*

East Franklin Street has seen countless business come and go in the last fifty years, but Ye Old Waffle Shoppe has been a constant. In 1972, Jimmy and Linda Chris took over a space that had been home to Crabtree's Soda Fountain in the 1920s and then Vernon Lacock's Shu-Fixery for many years afterward. Using wood beams salvaged from a Greek Orthodox church in Winston-Salem where the couple was married in 1968, the Chrises renovated the narrow space. An open grill was set up behind a long seating counter, and booths were installed in the back of the space.

Ye Ole Waffle Shoppe in the late 1970s. *Courtesy Chapel Hill Historical Society Collection, Digital NC.*

106

("We have an open kitchen up front so we can get to know customers on a name basis," Chris told the *Daily Tar Heel* in 1998.) The menu was nothing fancy—just breakfast classics any time of day, including waffles and pancakes (of course) but also omelets and sandwiches. Thanks to good prices, fast service and coffee mugs that were kept full, it soon became a town favorite. Little has changed over the years, and Ye Olde Waffle Shoppe is now a legendary Chapel Hill eatery.

ZOOM-ZOOM

104 W. Franklin

When I was a little kid in the late '60s, Zoom-Zoom was special for me. When my mother wanted to go shopping downtown, she got my brother and I to tag along by promising lunch at the Zoom-Zoom. It was sort of the carrot she dangled in front of us. We always wanted to go there, and I still remember the pictures of the animals that covered the walls.

—James McWhorter

In 1960, Ted and Bibi Danziger opened their third restaurant. Located just a few yards from Columbia Street in the first block of West Franklin, Zoom-Zoom took over a location that had been a laundromat. The new restaurant offered a menu designed to appeal to cost-conscious students and included such items as pizza, beef stroganoff casserole, barbecue and

Zoom-Zoom at 104 West Franklin Street. It was replaced around 1980 by a Mr. Gatti's Pizza franchise. In 1986, the location was taken over by Bruegger's Bagel Bakery. *Courtesy Chapel Hill Historical Society Collection, University of North Carolina–Chapel Hill.*

lasagna. Zoom-Zoom even offered delivery to campus dorm rooms for thirty-five cents in its early years.

The basement space below the Zoom-Zoom was converted into another Danziger establishment called the Bacchae. With an entrance on Columbia Street, it began as a restaurant in 1970 but soon transformed into a bar and nightclub. Zoom-Zoom closed in 1980 and was replaced by a Mr. Gatti's Pizza franchise. It was followed by Bruegger's Bagel Bakery, which had a much longer existence.

3

Carrboro

Though Chapel Hill and Carrboro seamlessly join near where Franklin and Rosemary Streets merge, the two towns had very different histories for many years. While Chapel Hill was built around the University of North Carolina, Carrboro's beginnings can be traced to a train depot that opened nearly ninety years later. An unincorporated community called West End sprang up around the depot in the 1880s. By the late 1890s, the town became home to the first of several textile mills built near the tracks. Around them, the town that eventually became known as Carrboro began as a traditional southern mill village made of numerous small mill houses.

By the 1960s, the mills were shutting down. With them went many of the businesses that had been supported by their workers, including several cafés and cafeterias. The neighboring university was growing, however, and Carrboro soon became a popular site for students to find off-campus housing. The town was also an affordable housing option for those who worked in Chapel Hill or the Research Triangle Park. Growth eventually led to Carrboro being seen as a promising location for restaurateurs. Some of those early eateries in the new generation included Martini's, an Italian restaurant on West Main Street; the Red Baron, a seafood restaurant on Jones Ferry; and, in the old train depot, the Station, which had a southern theme. Today, the restaurant scene in Carrboro is bustling, and though it is very closely linked with Chapel Hill, the town proudly maintains its own identity. The following are a few restaurants that have helped shape the town.

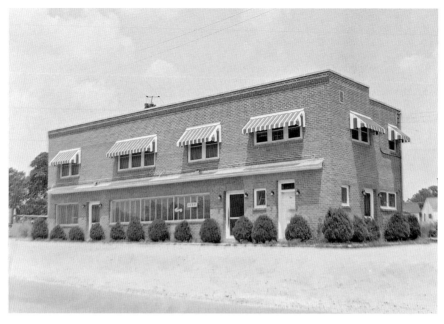

Ivey's was the first of many restaurants to occupy the building at 206 West Main Street. It was short-lived, but in the fall of 1949, it was the subject of a news article in the *Daily Tar Heel* because it featured the first public television set in the county. A 1950 advertisement offered customers "a good television show each night on the large 16-inch screen." The building has also been home to other firsts: Carrboro's first pizza in 1957 when La Pizza opened and the town's first sushi at Akai Hana in 1997. *Courtesy Roland Giduz Photographic Collection, University of North Carolina–Chapel Hill.*

Customers inside La Pizza in 1962. Advertisements noted that the establishment, which opened in 1957, offered air conditioning, soft music and candlelight, in addition to delivery service. As late as 1966, it still proclaimed to be the only pizzeria in town. *Courtesy Roland Giduz Photographic Collection, University of North Carolina–Chapel Hill.*

The Carrboro railroad depot, constructed in the 1880s, was the arrival and departure point for many UNC students. After its original use ended, it became the location of several restaurants, including the Station, shown here in the late 1970s. In 1981, it became the site of the Orient Express, which offered fine dining. A 1914 Pullman railcar was brought in from Georgia and parked next to the depot. In it was served a European-themed menu. It closed in 1991. *Courtesy Chapel Hill Historical Society Collection, University of North Carolina–Chapel Hill.*

ACME

110 East Main Street

Chef and owner Kevin Callaghan, a UNC graduate, launched Acme Food & Beverage Company in 1998. On opening, he told the *Daily Tar Heel* that he chose Carrboro because of its diversity and the fact that "it is a small town that affords all the amenities of big-city life."

Now more than twenty years old, Callaghan's restaurant has found success serving cuisine that, according to its own description, "draws inspiration from the seasonal rhythms and flavors of his childhood and uses fresh local ingredients to create Southern American dishes in a fine dining setting." In addition to remaining a local favorite, Acme has been featured in *Southern Living*, *Bon Appétit*, *Garden & Gun*, the *New York Times* and many other publications.

Josh Seay talks with the cashier at Akai Hana in the late 1990s. Seay, whose mother and stepfather owned the restaurant, was a well-known figure around Chapel Hill. In addition to restaurant duties, he played the piano to entertain customers on Saturday nights for eight years before his untimely death. *Courtesy Lee Smith and Hal Crowther.*

Carrboro's Armadillo Grill has been serving casual Mexican food since 1993. *Photo by Mark Dolejs. Courtesy Durham Herald Collection, University of North Carolina– Chapel Hill.*

AKAI HANA

206 West Main Street

When we opened Akai Hana, everyone told us we were crazy. They said we were too far from downtown Chapel Hill, no students would come, restaurant people won't go to Carrboro and nobody is going to eat sushi. The guys that worked in the auto shop next door, they would keep coming over when we were under construction and would say, "when is the bait shop going to open?" Now, look at Carrboro!

—Lee Smith

Akai Hana, a name that means "red flower," was founded in 1997 as the first and only Japanese restaurant in Carrboro. It opened in a building with a restaurant history dating to the 1940s and has had a much longer existence than any of the previous tenants (Ivey's, La Pizza, Martini's and Maggie's Muffins). Bob Huneycutt, original manager of the popular sushi restaurant, eventually purchased it. With his commitment to authenticity, Akai Hana remains a destination for sushi for the entire Triangle area.

ARMADILLO GRILL

120 East Main Street

With the slogan "Fresh Tex-Mex in Carolina," Armadillo Grill opened in 1993 in a building that had once been a grocery store. In an interview with the *Daily Tar Heel*, founder Ben Pace stated, "It seemed so logical to open up a place in this area." The restaurant focused on fresh food that was never frozen and affordable prices. The model worked, and Armadillo Grill has remained a popular dining option for students and families alike for over twenty-five years.

AURORA

Carr Mill Mall, 200 North Greensboro Street

Seeking to expand Italian cuisine beyond the spaghetti and lasagna that so often defined it in this country at the time, Aurora opened in 1976 on Franklin Street. An early review in the *Daily Tar Heel* stated, "The restaurant seems transplanted from New York or San Francisco. Down here in the fried chicken and honey biscuit belt, Aurora is pure serendipity at reasonable cost."

In 1982, Aurora moved to Carr Mill Mall, the old textile mill that had been turned into a retail space. Hank Straus, who began as a waiter and

Aurora, which served northern Italian cuisine, opened in 1976 on Franklin Street in Chapel Hill. In the early 1980s, it moved to Carrboro's renovated Carr Mill Mall. There it established itself as one of the area's top restaurants. It moved again, back to Chapel Hill, in 1998. *Courtesy Durham Herald Collection, University of North Carolina–Chapel Hill.*

then became an assistant manager, took over ownership of the restaurant in 1984. He helped Aurora set the fine-dining standard for Italian food in the Triangle.

Seeking a larger space, Straus moved Aurora back to Chapel Hill and took over the Pines' old space in 1998. It continued until 2007, when the land was sold for redevelopment.

CARRBURRITOS TAQUIERA

711 West Rosemary Street

Gail and Bill Fairbanks, who had run a restaurant in California, knew how popular burritos were in that state. After moving to North Carolina, they decided to open cafeteria-style Carrburritos in a small space at the intersection of Franklin and Rosemary Streets in 1997. With burritos that focused on fresh ingredients, ceviche, a diverse selection of salsas and an outdoor patio, the restaurant soon developed a loyal following.

The complimentary salsas the restaurant offered proved so popular that the Fairbankses decided to sell their chipotle salsa in jars in 2010. A year later, they added a second Carrburritos location in the college town of Davidson. Today, Carrburritos is run by their daughter, Rae Mosher, and remains extremely popular.

ELMO'S

Carr Mill Mall, 193 North Greensboro Street

Elmo's is the definition of a classic, comfortable diner. Since 1996, it has been Carrboro's destination for breakfast (served any time of day) and has won numerous awards from *Indy Week* for best breakfast in the area. Though omelets and pancakes are the choice for many, Elmo's also serves a full menu of burgers and comfort food.

After the owners realized they had so many customers coming from Durham, they decided to open a second location there in 1997.

JADE PALACE

103 East Main Street

Carrboro's first Chinese restaurant has a history longer than any other in the town. Francis Chan, a UNC graduate student at the time, and his wife, Jenny, opened Jade Palace in 1982 after seeing a lack of Chinese cuisine. In the early years, the clientele usually consisted of members of the small group of Chinese people living in the area. Eventually, that group grew, word of the restaurant spread to the student population and the popularity of Jade Palace increased greatly. In 2008, the restaurant was taken over by the Chans' nephew, Kevin Wang. He has maintained Jade Palace's commitment to authentic Chinese cuisine.

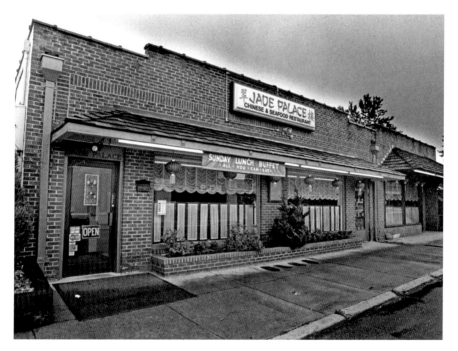

Jade Palace, seen here in 1990, has been serving Chinese cuisine since 1982. *Photo by Chuck Liddy. Courtesy Durham Herald Collection, University of North Carolina–Chapel Hill.*

MILL TOWN

307 East Main Street

With a name that was a tribute to Carrboro's heritage, brothers Josh and Drew Wittman opened Mill Town in 2005. Perhaps not surprisingly, due to Carrboro's penchant for uniqueness, it focused on Belgian beer and offered specialties such as Belgian-style fries and mussel dishes.

Decorated with vintage beer signs and providing an outdoor seating area, Mill Town was a popular place for weekend brunch or to watch a big game on television. It was also known for its celebrations of numerous holidays, such as Octoberfest, Cinco de Mayo and Saint Patrick's Day. Mill Town closed in 2019.

NEAL'S DELI

100 East Main Street

As the son of Bill and Moreton Neal, Matt Neal can be considered something of culinary royalty. He worked in his parents' restaurants and others while growing up but decided to follow another path. Neal eventually realized food was his true calling, and he returned to the area. In 2008, in a narrow space in Carrboro, he and his wife, Sheila, opened Neal's Deli. Open for breakfast and lunch, it focuses on traditional deli fare (such as Italian subs) with a distinctive southern touch. In 2017, the eatery was even highlighted in *Food and Wine* magazine for its famous pastrami sandwich served on buttermilk biscuits.

SPRING GARDEN BAR & GRILL/SPOTTED DOG

111 East Main Street

The first Spring Garden Bar & Grill opened on the street of the same name in Greensboro in the early 1980s. The establishment was popular, and other locations were soon opened in Winston-Salem and elsewhere in Greensboro.

In 1986, a Carrboro location opened in a circa-1915 downtown building that had once been the town's post office and was most recently a pool hall called Bullwinkle's. Spring Garden proved popular for its burgers and soon became a required stop for barhopping students and was even listed as Hole no. 1 in the *Daily Tar Heel*'s guide to bar golf in 1989. In the mid-1990s, the owners of the Spring Garden chain decided to focus on brewing beer and closed their restaurants. (Red Oak Brewery, located off I-85/40 between Burlington and Greensboro, is the descendent of the Spring Garden chain.)

In 1998, UNC graduates Linda Bourne and Karin Mills opened Spotted Dog in the space. It soon developed a loyal following for its large number of vegetarian offerings. A new owner bought the popular eatery in 2016, but the name remained the same, and the menu changed little. It remains one of Carrboro's most venerable eateries well over two decades later.

TYLER'S RESTAURANT AND TAPROOM

102 East Main Street

With the goal of creating a modern neighborhood pub, UNC alums Tyler and Celeste Huntington opened Tyler's in 1998. "I'm really going for a community-oriented feel, and that's what Carrboro offers," Tyler Huntington told the *Daily Tar Heel*. The restaurant soon became known for its large selection of draft beer and creative bar food. The business even expanded into neighboring spaces on Main Street and opened a bar known as Tyler's Speakeasy, as well as Carrboro Bottle Shop, a beverage store.

The model for Tyler's proved successful, and a second location opened in Durham's American Tobacco Complex in 2004. It enjoyed a fifteen-year run before closing in 2019.

WEAVER STREET MARKET

101 East Weaver Street

While perhaps not a restaurant in the usual definition of the word, Weaver Street Market has been serving meals to Carrboro residents since it opened

in 1988. Located in the Carr Mill Mall complex, the market is a customer-owned cooperative that focuses on selling natural and organic food. It is the popular self-serve hot food and salad bars that have made Weaver Street an important part of Carrboro restaurant culture. The large park-like outdoor seating area, often packed with diners, has, in many ways, become the cultural heart of the town.

The Carrboro Weaver Street Market proved so successful that other locations were opened in downtown Hillsborough, Chapel Hill's Southern Village and downtown Raleigh.

4
Hillsborough

An important colonial town years before Chapel Hill was founded, Hillsborough is the oldest of Orange County's three municipalities. It has been the county seat since 1754 and the center of political activity. Because of this, downtown has a historic and decidedly genteel air about it. In the western part of town, textile mills were built in the late 1800s. This resulted in the growth of mill villages—much like Carrboro—which added to the diversity of the town. In recent years, as Chapel Hill and Durham have grown, their proximity to Hillsborough has made the town a popular housing option for commuters.

Like most towns its size, Hillsborough has dining options that run from home cooking and barbecue to quite fancy. That means a little more in this town, however. Southern home-cooked meals were served at one of the state's oldest inns for over a century and a half (and will be again), barbecue is served at an acclaimed eatery and fancy can mean a farm-to-fork restaurant led by a chef who has been a James Beard award finalist. Among the town's eateries are places as diverse as Jack's Country Restaurant, a no-frills café that has been serving a home-cooked breakfast and lunch for years in the Boone Square shopping center. Down the parking lot from Jack's is the Dog House, which has other locations in Durham. It has been serving take-out hot dogs from its distinctive buildings since the 1970s. For barbecue, it's the wood-smoked pork shoulders from Hillsborough BBQ Company in the west side of town on Nash Street. It opened in 2011 and has earned praise from *Our State* magazine and WUNC-TV's *North Carolina Weekend*. Panciuto is the town's most acclaimed restaurant. Its chef/owner has been in the

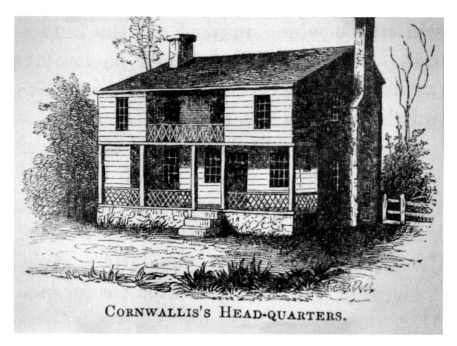

CORNWALLIS'S HEAD-QUARTERS.

It was in the county's taverns and boardinghouses where the first meals were served outside the home. Faddis tavern, located just off King Street in Hillsborough, across from where the Orange County courthouse is now, even served as the headquarters of British general Cornwallis when he occupied the town in 1781. It remained in operation through the 1800s. *Courtesy Orange County Historical Museum.*

running for a James Beard award multiple times. Overall, Hillsborough has a surprisingly rich restaurant culture that is continuing to grow as the town's population increases.

Like Chapel Hill and Carrboro, Hillsborough has locations that have housed numerous restaurants over the years. The James Pharmacy building at 111 North Churton Street is one. Built in the early 1920s, the pharmacy for which it was named featured a traditional soda counter and served lunch. By 1987, it had closed, and a new sandwich shop named Lu-E-G's opened. That eatery, known for its vegetarian offerings, remained a popular lunch spot until 2002. It was replaced by the James Pharmacy Restaurant (2002–4), which became Flying Fish (2005–8). It was sold in 2008, and the name changed to Gulf Rim, but the menu remained much the same. In 2014, it was transformed into LaPlace Louisiana Cookery. In 2019, a new restaurant with a seafood-themed menu opened under the building's original name, James Pharmacy.

Another address with a long restaurant history is 101 North Churton. The 1920s brick building has had many tenants over the years, including a drugstore and a short-lived Italian restaurant. Cajun-themed Tupelo's then had a run of a decade before being replaced by Antonia's in 2011. It remains one of the town's most popular eateries. Overall, Hillsborough's food scene continues to evolve, diversify and grow, much like the town itself.

The following are a few of the eating establishments that have contributed to the town's restaurant history.

COLONIAL INN

153 West King Street

It was such a tragedy when the Colonial Inn was closed for so long. So many people have these memories of going there all dressed up with their whole family after church. When I lived in Chapel Hill and my parents would come, we would drive up to Hillsborough and have a big lunch. Everybody did that with their family. And so many students at Carolina and their parents would come. There was a whole tradition. It was so big for so many families.

—Lee Smith

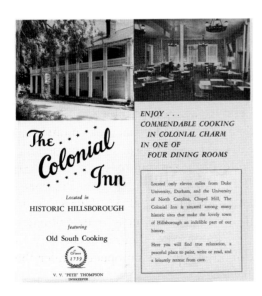

A 1970s brochure promoting dining at the Colonial Inn. *Courtesy Orange County Historical Museum.*

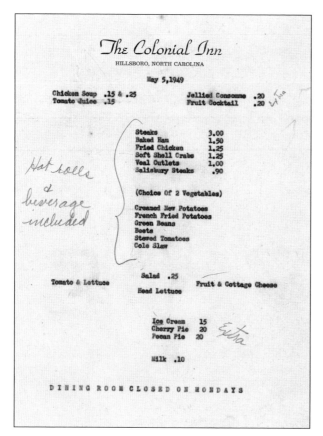

This menu dates to 1949, when the Colonial Inn was becoming known for its restaurant. A small piece of paper was attached to the reverse of the menu, offering a "Special Lobster Dinner," complete with shrimp cocktail, French fries, tossed salad, hot rolls and tea for three dollars. *Courtesy Orange County Historical Museum.*

Perhaps the most famous restaurant in Hillsborough was the one at the Colonial Inn. Founded in the first half of the nineteenth century, the inn has a long and complicated history that is worth a book itself. It went through numerous owners and even names, but it was in the 1940s, during the ownership of Paul Henderson, that a restaurant was added. It soon became a destination for diners, particularly for its Sunday family-style dinners. Lois and V.V. "Pete" Thompson, who owned the inn from 1969 to 1985, continued this tradition.

The restaurant served its last meal in April 2001. The building was sold at auction not long after but remained empty and neglected for years. As of this writing, the historic inn is finally undergoing an extensive renovation.

SARATOGA GRILL

108 South Churton Street

In the late 1980s and early 1990s, one of the few consistently good restaurants in Hillsborough was the Regulator Café. Known for natural foods and vegetarian dishes, it was run by John Troy and his wife, Carol, for several years in an upstairs space overlooking Churton Street. In 1995, Colleen and Kevin St. John took over the location and transformed the restaurant into the Saratoga Grill. Its somewhat upscale yet unpretentious atmosphere, combined with a varied American menu, soon made Saratoga a town favorite. It remains one of those few restaurants that seem to have found its niche in a community through a combination of food, service and atmosphere.

Hillsborough's Regulator Cafe in 1991. In 1995, the upstairs location became Saratoga Grill, which was still going strong twenty-five years later. *Photo by Jim Thornton. Courtesy Durham Herald Collection, University of North Carolina– Chapel Hill.*

PANCIUTO

110 South Churton Street

At our first meal at Panciuto in 2007, my husband insisted I take a bite of his Ossabaw heritage pork chop. It was like no pork chop I'd ever tasted, and I immediately ordered one for myself. There wasn't another chop, but on our next visit, a lovely one appeared next to my plate. They didn't forget.

There have been many stunning meals since, though it's impossible to find those chops now. Amazing things happen to the humblest of vegetables, fruits from abandoned trees, wild pawpaws, fish you haven't tried before, carpaccio….Everything bears the stamp of Aaron Vandemark's imagination and wit, served in the warm comfort of a neighborhood restaurant that happens to be nationally celebrated.

—Fran McCullough

To some, it might be surprising to find one of the most highly acclaimed restaurants in the entire South in a town the size of Hillsborough. But that is exactly what Panciuto is. Chef/owner Aaron Vandemark opened his establishment in 2006 with the goal of creating a restaurant that had an Italian theme but worked with southern, farm-to-fork ingredients. The idea worked, and it led to Vandemark being named a semifinalist for the James Beard award for Best Chef: Southeast six times, as well as earning Panciuto features in publications including the, *Bon Appétit*, *Garden and Gun* and the *New York Times*.

VILLAGE DINER

600 West King Street

Ethel and Hammie Stansbury founded the Village Diner in 1975. For over forty years, it quietly served home-style southern staples. At its popular lunch buffet could be found everyone from local politicians to attorneys in suits to construction workers in hardhats.

When Ethel Stansbury retired in 2010, her daughter, Teresa Pelfrey, took over. After a few years, it became apparent that the restaurant needed an update. They didn't have to go far to find a new owner. Joel Bohlin, who

Matt Fox, owner of the Wooden Nickel, and his wife, Shannon, in front of the establishment's first location. *Courtesy Stella and Birdie Photography.*

was the general manager at Hillsborough BBQ Company, saw it as an opportunity to express his culinary creativity. He took over ownership of the Village Diner in 2017 and gave both the interior and the menu a major facelift. Since reopening, Bohlin's innovative southern dishes (including his versions of pizza) have earned the restaurant acclaim, as well as a feature in *Our State* magazine.

THE WOODEN NICKEL

105 North Churton Street/113 North Churton Street

I can remember when you could walk along the Churton Street sidewalk on a Friday night in the late '90s and not see a soul nor a passing car at 8:00 p.m. It wasn't until 2003 that life was breathed into the downtown and energized by a new establishment called the Wooden Nickel. It quickly became the local watering hole that all of the local people in town visited. It was the Cheers *of Hillsborough, and it spawned many friendships and relationships that have helped weave the fabric of this great little town. The*

Nickel, as the locals call it, has provided many respites from a busy day or a hot summer afternoon, as well as many delicious meals. If the walls could talk—and they almost do with their charcoal portraits of the regulars—they would tell you of the many memory-making events it has been part of. My wife, Jaime, and I are one of those memories, as we shared our wedding reception there on October 12, 2013. The Nickel is the backbone of the social and dining network in Hillsborough, may it live on forever.

—Jim Parker

In a small space that had been Kelsey's Café in the 1990s, the Wooden Nickel opened in 2003. Soon regarded as Hillsborough's neighborhood pub, it became so popular that finding a seat required a wait. It wasn't just the bar that brought in patrons, the Wooden Nickel also focused on creating a menu that offered inspired versions of classic burgers and sandwiches. Its tater tots and wings also developed a loyal following.

In 2017, owner Matt Fox moved the Nickel two doors down to a much larger space that had once been the town's Chevrolet dealership. With expanded indoor and outdoor seating (and beer selection) the Wooden Nickel remains the heart of Hillsborough's downtown community.

Bibliography

Newspapers and Magazines

Carolina Alumni Review
Chapel Hill Magazine
Daily Tar Heel
Durham Herald
Hill's Chapel Hill City Directory
Indy Week
Los Angeles Times
New York Times
Our State
Raleigh News and Observer
Southern Living
The Sun
Triangle Business Journal

Books

Bryant, Bernard Lee, Jr. *Occupants and Structures of Franklin Street, Chapel Hill, North Carolina at 5-Year Intervals, 1793–1998.* Chapel Hill, NC: Chapel Hill Historical Society, 1999.

Chansky, Art. *Game Changers: Dean Smith, Charlie Scott, and the Era That Transformed a Southern College Town.* Chapel Hill: University of North Carolina Press, 2016.

Cohen Ferris, Marcie. *The Edible South: The Power of Food and the Making of an American Region.* Chapel Hill: University of North Carolina Press, 2016.

Edge, John T. *The Potlikker Papers: A Food History of the Modern South.* New York: Penguin Press, 2017.

Giduz, Roland. *Conversations on the Wall: Cameron Henderson on Chapel Hill.* Bloomington, IN: iUniverse, 2001.

Haley, Andrew P. *Turning the Tables: Restaurants and the Rise of the American Middle Class, 1880–1920.* Chapel Hill: University of North Carolina Press, 2011.

Hines, Duncan. *Adventures in Good Eating: Good Eating Places along the Highways and in Cities of America.* Bowing Green, KY: Adventures in Good Eating, 1945.

Little, Ruth. *The Town and Gown Architecture of Chapel Hill, North Carolina, 1795–1975.* Chapel Hill: University of North Carolina Press, 2006.

Neal, Moreton. *Remembering Bill Neal: Favorite Recipes from a Life in Cooking.* Chapel Hill: University of North Carolina Press, 2004.

Prospero, Ann. *Chefs of the Triangle: Their Lives, Recipes and Restaurants.* Winston-Salem, NC: John F. Blair Publishers, 2009.

Reed, John Shelton, and Dale Volberg Reed. *Holy Smoke: The Big Book of North Carolina Barbecue.* Chapel Hill: University of North Carolina Press, 2008.

Vickers, James. *Chapel Hill: An Illustrated History.* Carrboro, NC: Barclay Publishers, 1985.

Other Sources

Durham Herald. Newspaper Photograph Collection #P0105. North Carolina Collection Photographic Archives, Wilson Library, University of North Carolina–Chapel Hill.

Durwood Barbour Collection of North Carolina Postcards #P0077. North Carolina Collection Photographic Archives, Wilson Library, University of North Carolina–Chapel Hill.

Farm Security Administration. Office of War Information Collection, Library of Congress.

North Carolina Collection, Steve Gaddis Photograph Collection, Durham County Library.

North Carolina Digital Heritage Center. digitalnc.org.

Open Orange. https://openorangenc.org.

Roland Giduz Photographic Collection #P0033. North Carolina Collection Photographic Archives, Wilson Library, University of North Carolina–Chapel Hill.

Southern Foodways. southernfoodways.org.

UNC Photo Lab Collection, #P0031. North Carolina Collection Photographic Archives, Wilson Library, University of North Carolina–Chapel Hill.

Index

About the Authors

Chris Holaday lives in Durham and is the author of a number of books, including *Southern Breads* and several on the topic of baseball. He graduated from the University of North Carolina at Chapel Hill and received a master's degree in history from North Carolina Central University in Durham.

For nearly twenty years, Patrick Cullom has worked to preserve and ensure access to historic photographic materials. Since 2007, he has served as a visual materials processing archivist for the Wilson Special Collections Library at the University of North Carolina at Chapel Hill. Patrick grew up in Raleigh and is a proud North Carolina State University alumnus. As such, he is especially honored to play a part in preserving and sharing North Carolina's rich photographic history. He currently lives in Raleigh with his family and an assortment of four-legged furry friends.

Holaday and Cullom also collaborated on *Classic Restaurants of Durham*, which was published in early 2020.